WITHDRAWN

Table of Contents

Dedication

This book is dedicated to Jim Brando, aka "Brando," a very talented artist who had the foresight to realize the potential of creating a book with a talented photographer who saw the creative potential in his painting ability.

Brando has also become a good friend and deserves recognition and respect for his talent and personality. His professionalism and respect for the models made every shooting enjoyable and left the model with an extraordinary experience.

Being painted by Brando has become a status symbol. Many enjoyed the experience so much they called and asked to be painted again, so some models appear in more than one painting.

My kudos to Brando — a dedicated, professional artist willing to put his talent on the line to create this fine body of work. Working with Brando has been one of my best shooting experiences in my 25 years as a professional photographer.

I also have to give thanks to all the models that appear in the book; they made this book possible. Thank you, girls!

Art Ketchum

Introduction

*A*rt Ketchum, Photographer/Author/Lecturer, opened his first studio in 1978 as a wedding and portrait photographer. Ketchum's background in the years leading up to opening his studio was in marketing management with some of the largest photofinishing companies in the United States. However, having many employees and living the corporate life did not fulfill his creative desires.

After five years of doing portraits and weddings, Ketchum decided to make the transition into commercial photography. Ketchum moved his studio from a suburban studio to one in downtown Chicago and went after corporate and ad-agency business. Within a year, he had established a base of accounts that would support his lifestyle. In shooting commercial-type accounts, he made many contacts with talent agencies and models. Shooting talented models allowed Ketchum to build a more creative portfolio. Ketchum experimented with several lighting techniques and designed lighting for the accounts he solicited.

While shooting for hair and beauty salons, hair magazines, and the Midwest Beauty Show in Chicago, Ketchum designed hair lighting that showed the texture and beauty in the hair. When creating images for dance costume catalogs, he devised lighting to show the sequins and fabrics to help sell the costume and design. Art still shoots for some of these types of accounts and has done this for almost 25 years.

Painting the Body Beautiful resulted from the meeting of Jim Brando and realizing Brando's immense talent in body painting. Ketchum asked Brando if he would like to do a book project together. They discussed the project and brainstormed ways to turn it into a reality. Brando looked through magazines, books, and internet images to get ideas.

When it came time to shoot the actual images, the model would come into Ketchum's studio, and together they would discuss the ideas with the model. Ultimately, when they decided what idea would work best, Brando would start painting and Ketchum would set up an appropriate background to match the model's new, painted look.

Ketchum wanted many different backgrounds to keep the book from becoming boring and redundant. As you flip through the pages of *Painting the Body Beautiful*, you will see the variety in the images and backgrounds.

Ketchum chose the lighting style to illustrate the beauty, detail, and texture in Brando's paintings. When people see a model with jeans painted on them, they have to look carefully to realize they are painted on, not real, jeans. Brando's attention to detail in fabric folds, collars, wrinkles, holes, threads, and shadow create a true 3-dimensional feel.

Ketchum designed the lighting to also create a 3-dimensional feel to the images. Using one large soft box (5'x4') for the main light and a very large umbrella (6') for a fill set one and a half stops less than the main, creates a 3:1 light ratio that shows the painting on the body with more depth and detail. Adding both a hair light, generally one to two stops brighter than the main light, and a rim light, set at one stop less light than the main light and at 45° behind the model directly opposite from the main light, finishes the light style. In some cases, a background light was used to create a more defined spot on the background behind the model. Most images were created with this lighting style.

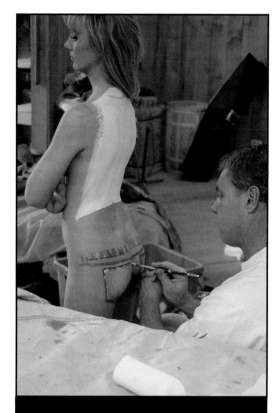

Brando paints realistic jeans on Jacki. The finished design can be seen on page 19.

The backgrounds were provided by Backdrop Outlet, and each was chosen for the unique painting on the specific model.

Working on this project for the three years it took to choose the models, paint each one, and photograph each setting, all with the objective of producing the book *Painting the Body Beautiful*, has been one of the most creative projects Ketchum and Brando have ever undertaken. Both men have a new understanding of each other's talent, and together they have created the most comprehensive book on body painting ever published.

While Brando painted the model, Ketchum shot images of the painting process to show Brando's painting technique. When finished, Ketchum brought the model on the set and created a diverse range of poses, and the best two or three shots would end up as the final selection in the book. Ketchum shot 150 to 300 images per model in order to have a diverse selection from which to choose.

Ketchum and Brando have created body-painted images for billboard road signs measuring 44 feet wide by 20 feet high. They also have a calendar coming out soon that features their images. They intend to continue their body painting endeavors in the future.

The camera equipment used in *Painting the Body Beautiful* consisted of Pentax digital cameras. During the beginning of the project, Ketchum used a Pentax *ist 6mp SLR camera and, later, a Pentax K-10 D 10mp. Now, Ketchum uses the Pentax K-20 D 14mp camera. Lenses included the Pentax 50mm, F:1.4, 70mm F:2.4, and a Pentax Zoom 18-250mm lens.

Visit Ketchum's Web site at **www.artketchum.com** for information on upcoming projects and monthly workshops, where photographers can shoot with live

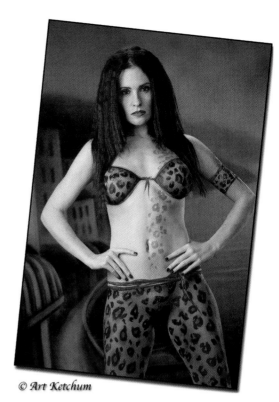

© Art Ketchum

models and learn how to create dynamic images with professional studio lighting and great posing ideas, all while building their own professional portfolio.

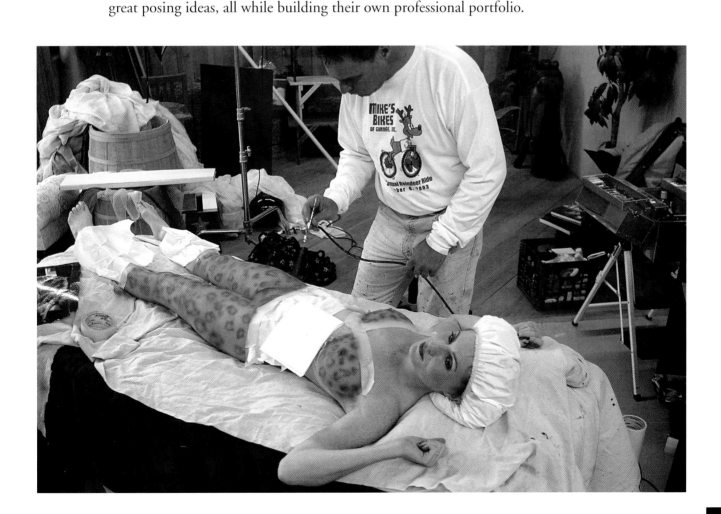

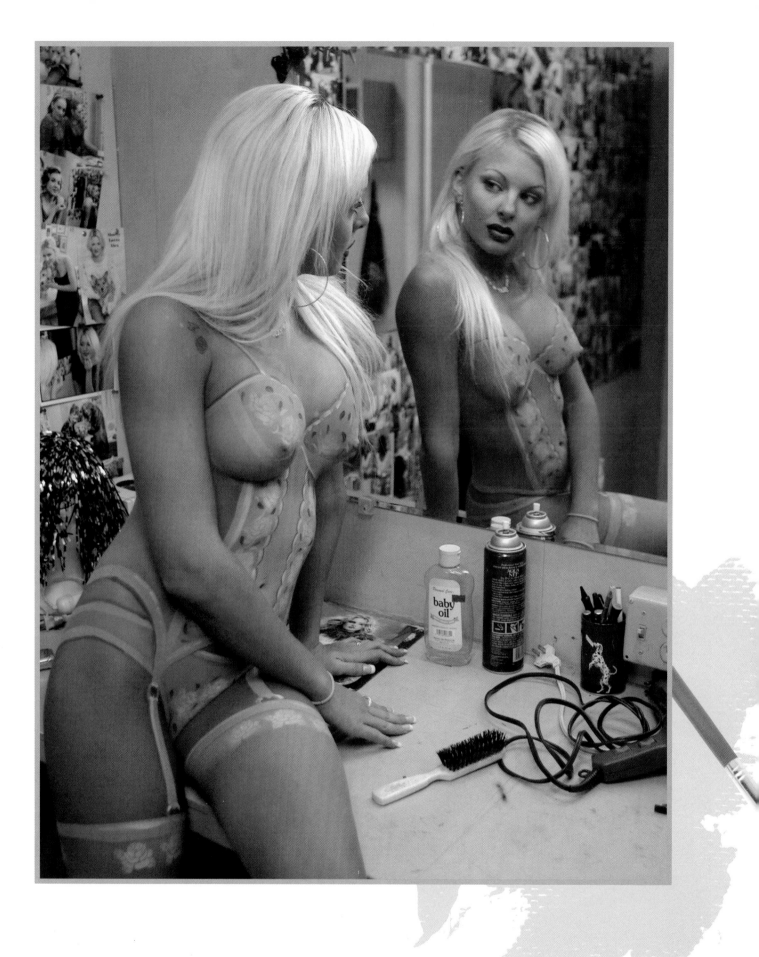

Painting the Body Beautiful

Painting

The nude female form is nearly ubiquitously regarded as a work of art. To Jim Brandonisio (aka "Brando"), it is just an empty canvas.

Jim Brando is a self-taught sign artist who began lettering and pin striping in 1973 at the age of 16. He took up his father's brushes only three years after his father's death and has been involved in the arts ever since. Besides a short stint at the American Academy of Art in Chicago, Jim's hands-on experiences have been his primary teacher. His work has been featured on the cars of some of the most notable drag racers in the country and has been published nationwide. Now, he focuses more locally on motorcycle detailing and has recently been working on a special project bike for Ducati.

Brando has worked with the internationally renowned photographer Art Ketchum for over three years, painting women for Ketchum to photograph for *Painting the Body Beautiful.* When asked about working with Brando, Ketchum says he is "one of the best; in fact, he is the best."

We had the opportunity to chronicle the body-painting process during a recent session with Brando and Ketchum. Model Stephanie Olson (at left) was to be painted with a realistic lingerie ensemble for the photo shoot. We managed to get Brando to break down the process and give a few pointers to those wishing to learn the art of body painting.

Following is a list of the materials Jim Brando used on this particular project (brand names can be substituted with equivalent products).

Painting Supplies

- Isopropyl Alcohol

- Eyeliner Pencil

- Masking Tape

- Mehron Barrier Spray Fixer and Sealer

- Mehron Liquid Makeup – Pink, Red, and White

- Mehron Mixing Liquid

- Barley Bikini Sliver paint

- Paradise Makeup LT Pink (BA. F-16), LT Brown (BA. G-02), Coral (BA. C-60), LT Green (BA. F-15), and White (BA. 4-91)

- Galeria Acrylic White Paint

- Hobby rose stencil

- Iwata Eclipse HP-CS Airbrush Gun with Gravity Feed Cup

- Sata Minijet Airbrush Gun (for larger spray areas)

- CO_2 Tank for airbrush pressure (30 pounds of pressure is needed)

- Assorted-width paint brushes

Painting a full body can take up to 12-16 ounces of paint, although this project required considerably less due to the size and sheerness of the outfit. The time elapsed during the process was 1 hour and 15 minutes, which can also vary depending on how much painting must be done and the speed at which one works (Brando works pretty fast, so do not get discouraged).

Step-by-Step

Step 1

Wipe down subject with isopropyl alcohol to clean and dry the skin.

Step 2

Mehron Barrier Spray Fixer and Sealer is applied as a primer for application of the paint (be sure to keep away from eyes).

Step 3

With an eyeliner pencil, draw an outline of your planned design as a guide.

Step 4

Apply masking tape to outline panty, thigh-high nylons, and neckline areas to keep lines straight and sharp.

Step 5

Cover up tattoos or other major discolorations using your LT Brown Paradise Makeup, mixed to match subject's skin tone, to prevent discolorations from showing through the paint.

Step 6

Using Pink Mehron Liquid Makeup, diluted with Mehron Mixing Liquid (for a lighter tone), and your Iwata Eclipse HP-CS Airbrush Gun with Gravity Feed Cup, fill in the areas by the masking tape. Apply heavy coverage to outlines, and slightly lighter coverage to the fills, to suggest "sheer" clothing. Dilution is used to create a lighter shade of pink.

Step 7

Remove masking tape from top of panty outline. Following the guide drawn with your eyeliner pencil, carefully outline and fill in the corset. The outline should be applied slightly heavier than the fill, to create the illusion of a hem.

Step 8

Spray on top of thigh-highs where masking tape was applied. The bottom of the line should be soft, as it will later "fade" into a sheer material.

Step 9

Create "stitching" in the corset by spraying thin, wavy vertical lines.

Step 10

Using a less diluted (darker) shade of pink, outline hems, stitching, and seams, and apply light shading from the boning along the sides of the corset. This will give the outfit more depth as further details are applied.

Step 11

Remove remainder of masking tape. With your LT Pink Paradise Makeup and a thick brush, paint in solid areas of the bra and trace the outlines of the corset.

Step 12

With the same brush, paint straight lines as "straps" connecting the corset and nylons. Leave a small gap on either end of the straps; those will later be filled with connecting grommets.

Step 13

Using a thinner brush, create bra straps and trace over the wavy stitching of the corset and neckline.

Step 14

Using the Silver Barely Bikini Paint and a fine brush, paint small metal grommets connecting the straps to the corset and nylons. Afterwards, cover a small portion at the top of the grommets with LT Pink Paradise Makeup to "wrap" the strap around it.

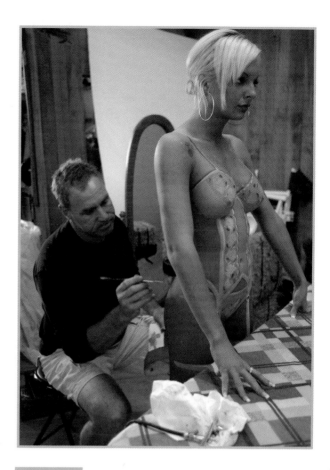

Step 15

With your stencil and White Mehron Liquid Makeup, spray a repeating floral pattern along either side of the corset.

Step 16

Using the Coral Paradise Makeup and a fine brush, add petal details around the white floral pattern.

Step 17

With the Green Paradise Makeup, add vines or leaves to the pattern.

Step 18

Again with the Coral Paradise Makeup, outline the stitching in the corset.

Step 19

Using a fine brush, create "shadows" along the outlines of the outfit with the Silver Barely Bikini Paint.

Step 20

With White Acrylic Paint, draw highlights along the boning, straps, and grommets.

Step 21

Add a stitching pattern to the hem of the outfit with White Acrylic Paint and a wide brush.

Step 22

At this point, have the subject stand up so you can complete the painting in the back. Repeat the steps with the masking tape, fills, outlines, and floral pattern to connect the back of the outfit to the front.

Step 23

Switching to your Sata Minijet Airbrush Gun (with a wider spray area), apply diluted Pink Mehron Liquid Makeup lightly to the legs to create the sheer nylons.

Step 24

With the White Acrylic Paint, finish up with a pearl necklace or any other accessory jewelry. Silver Barely Bikini Paint can be used for shadows/outlines.

Brando usually does not work with stencils because he prefers to paint freehand, but if you are repeating a particular pattern over and over again, Brando says that "it would have taken longer and been silly not to use it."

We asked Stephanie if the sensation was eerie or uncomfortable, and she replied that it was "just cold." According to Brando, she was a rather cooperative subject. "It's sometimes hard for them to sit still for the two hours it takes to paint," he recalled. "The most important thing is that the model is comfortable. We've had one model faint from standing too long because I guess she hadn't eaten for a while. And then there was one who was very ticklish, she just couldn't get through it. But usually it runs smoothly."

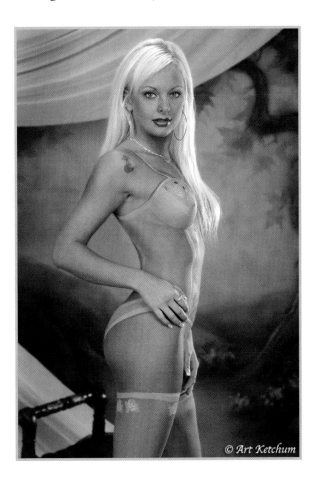

© Art Ketchum

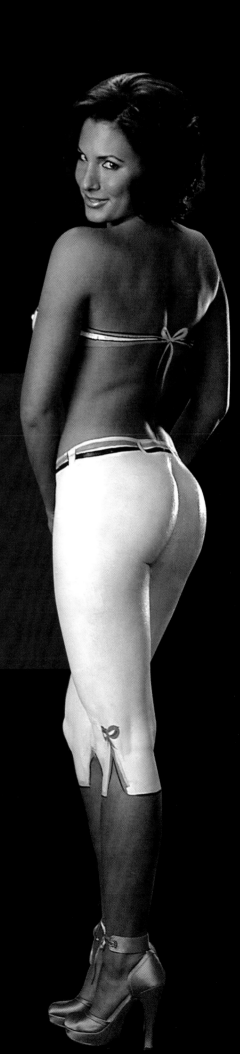

Clothing
& Swimwear

These body paintings are the ultimate
optical illusion. Each model in this section
is "wearing" nothing but fully painted,
exceptionally realistic clothing.

The Process

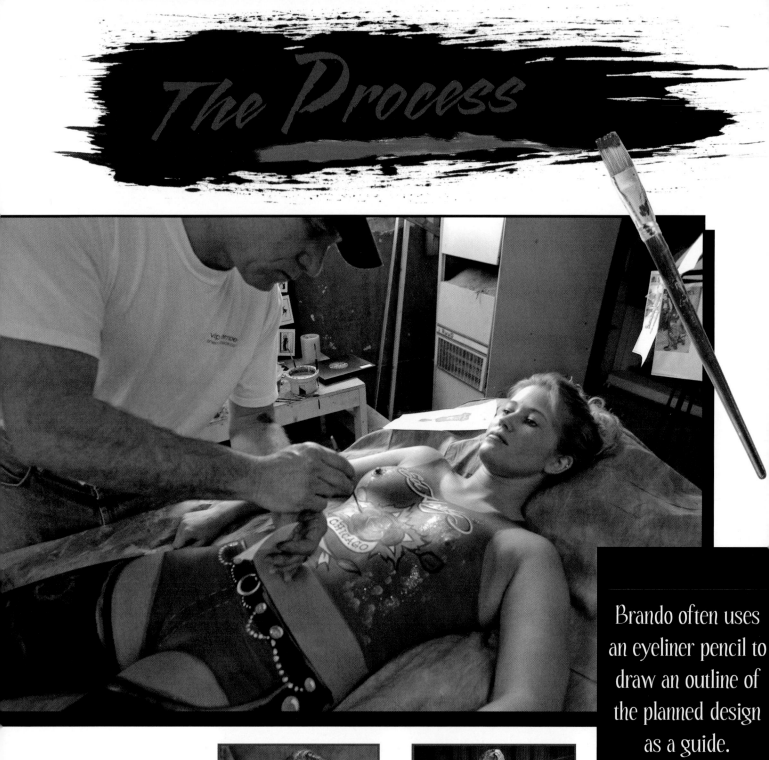

Brando often uses an eyeliner pencil to draw an outline of the planned design as a guide.

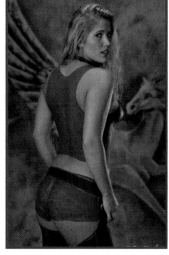

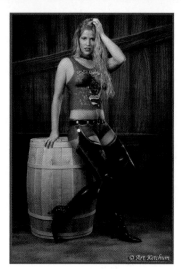

© Art Ketchum

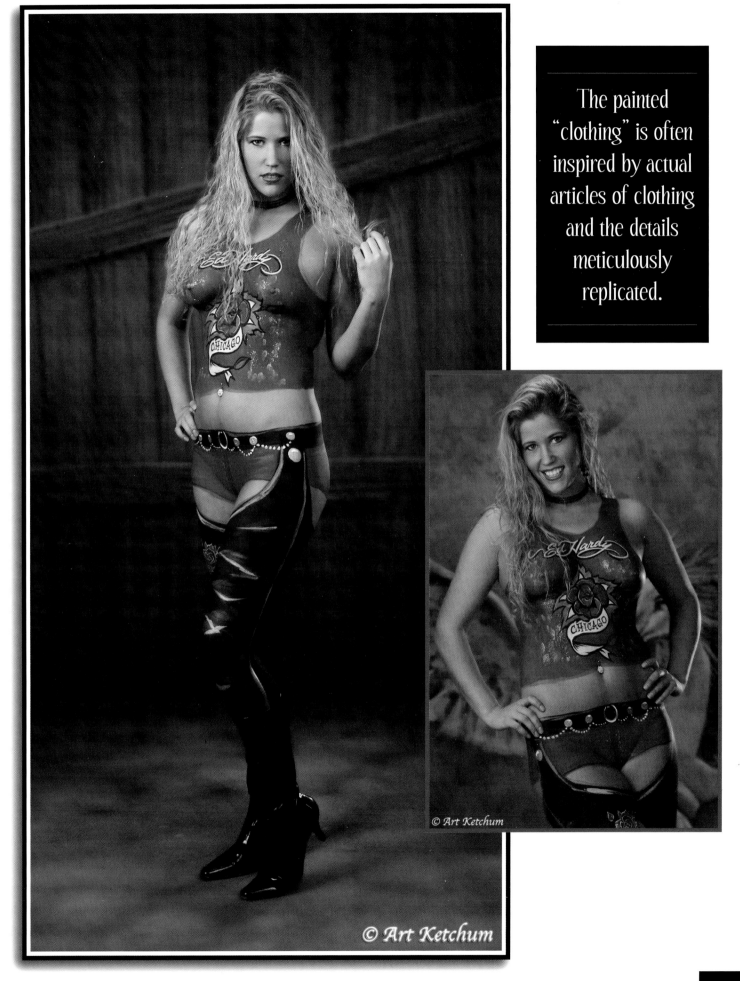

The painted "clothing" is often inspired by actual articles of clothing and the details meticulously replicated.

© Art Ketchum

© Art Ketchum

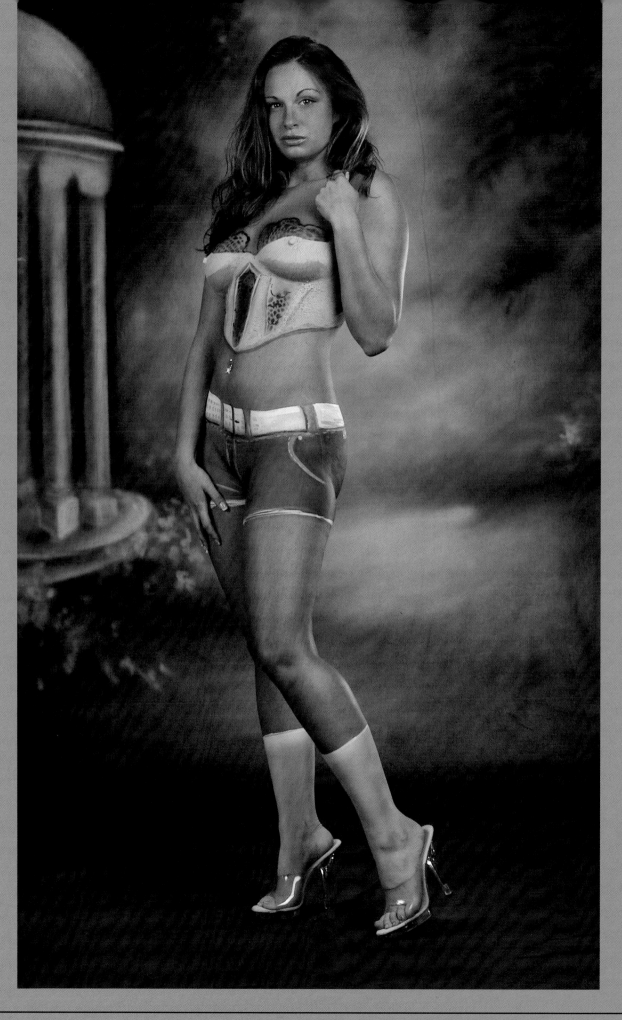

Painting the Body Beautiful

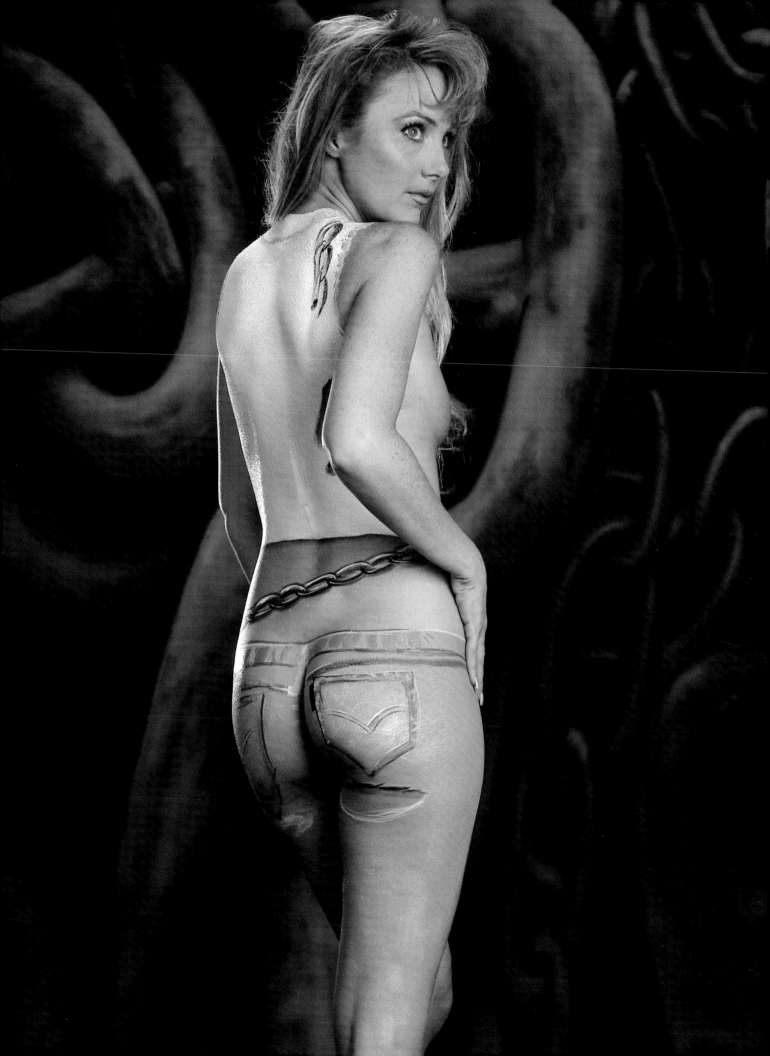

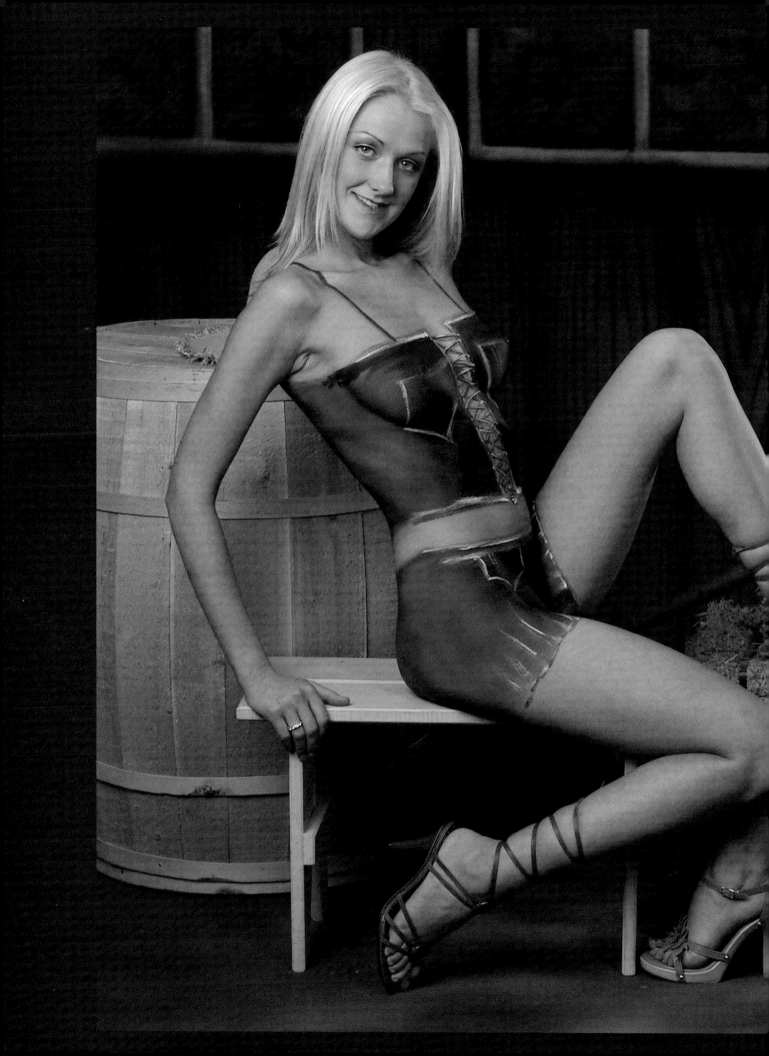

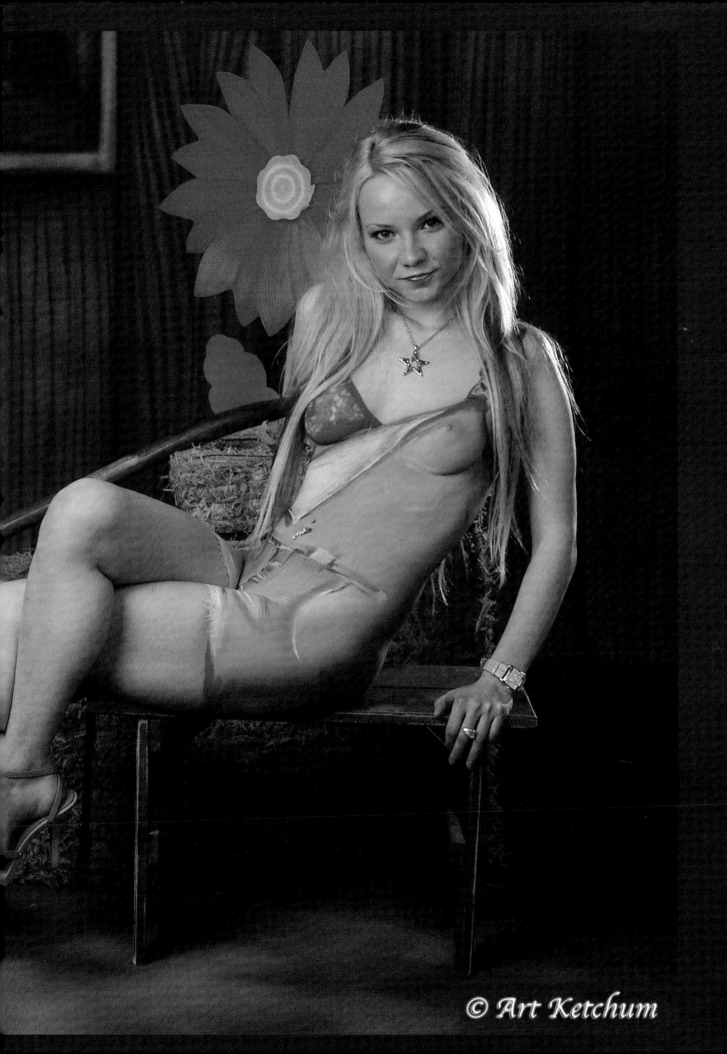

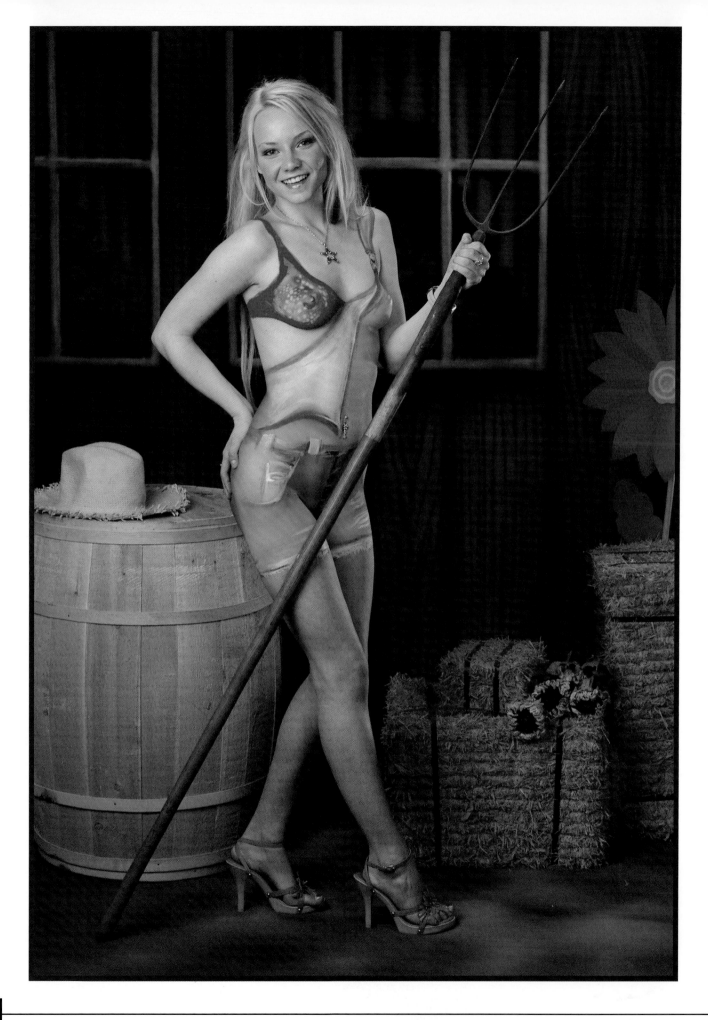

Painting the Body Beautiful

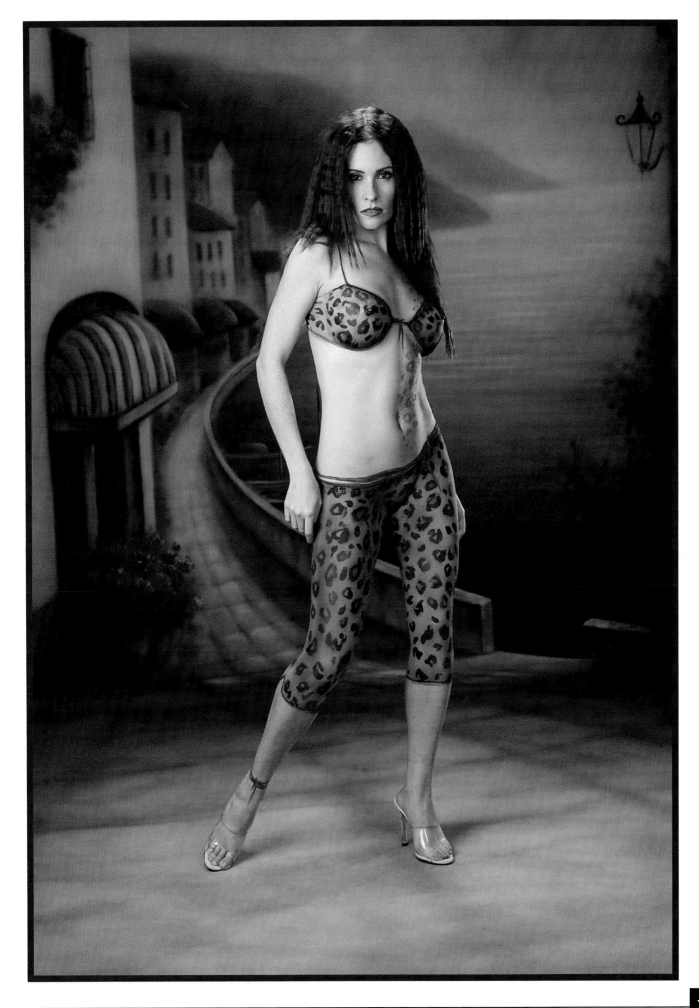

Clothing & Swimwear

Getting Ready

Painting a full body can take 12-16 oz. of paint.

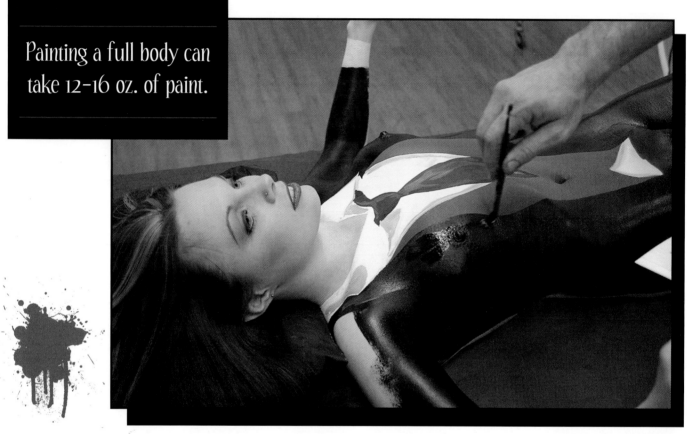

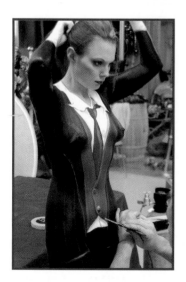
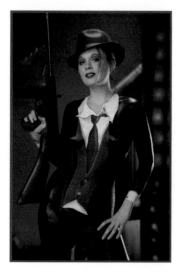
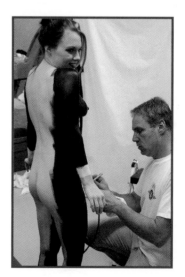
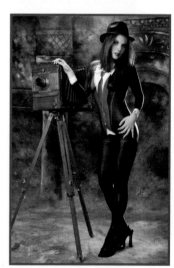

Painting the Body Beautiful

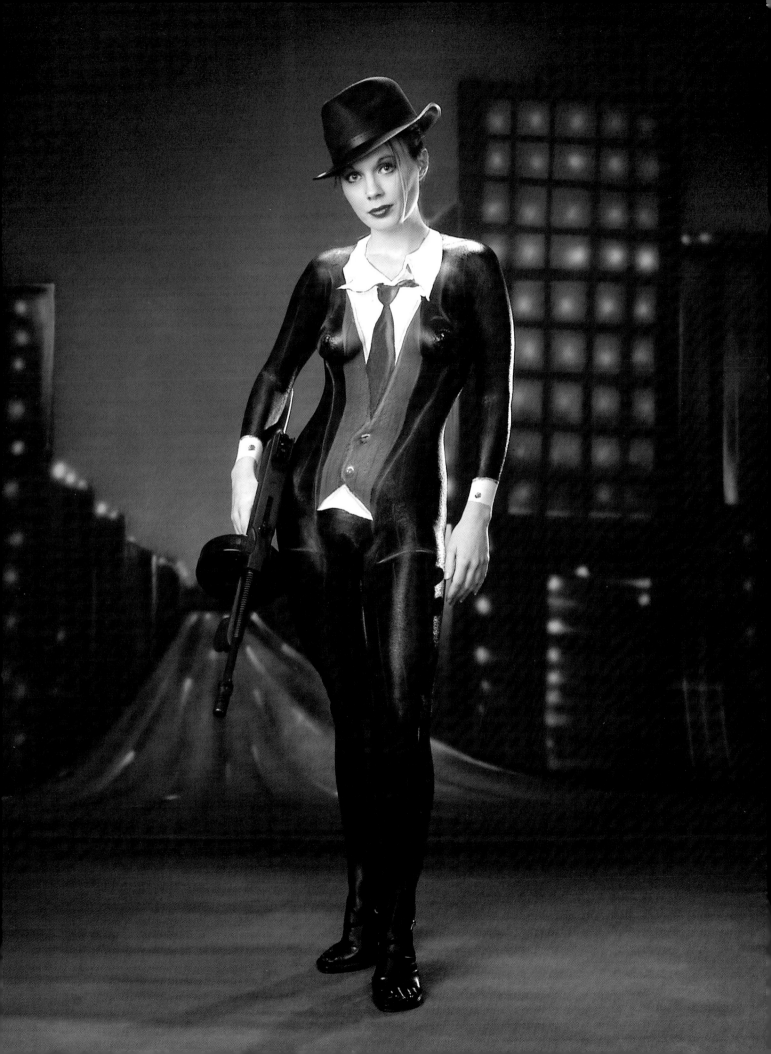

Painting

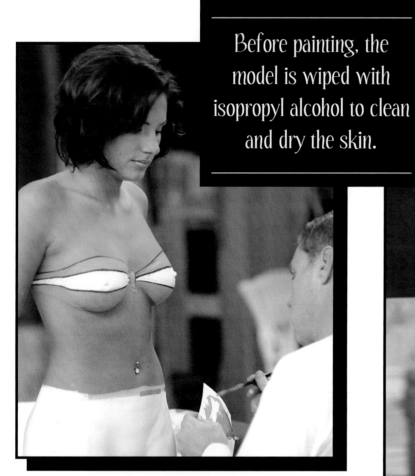

Before painting, the model is wiped with isopropyl alcohol to clean and dry the skin.

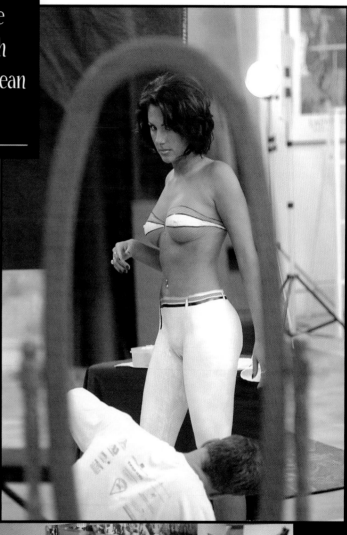

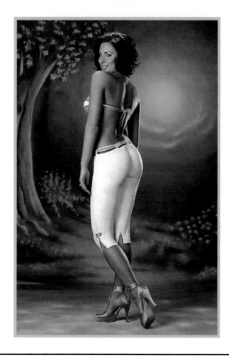

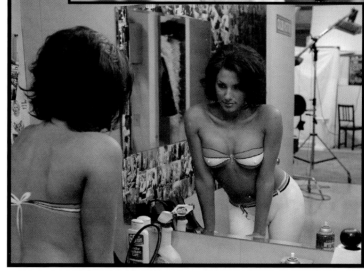

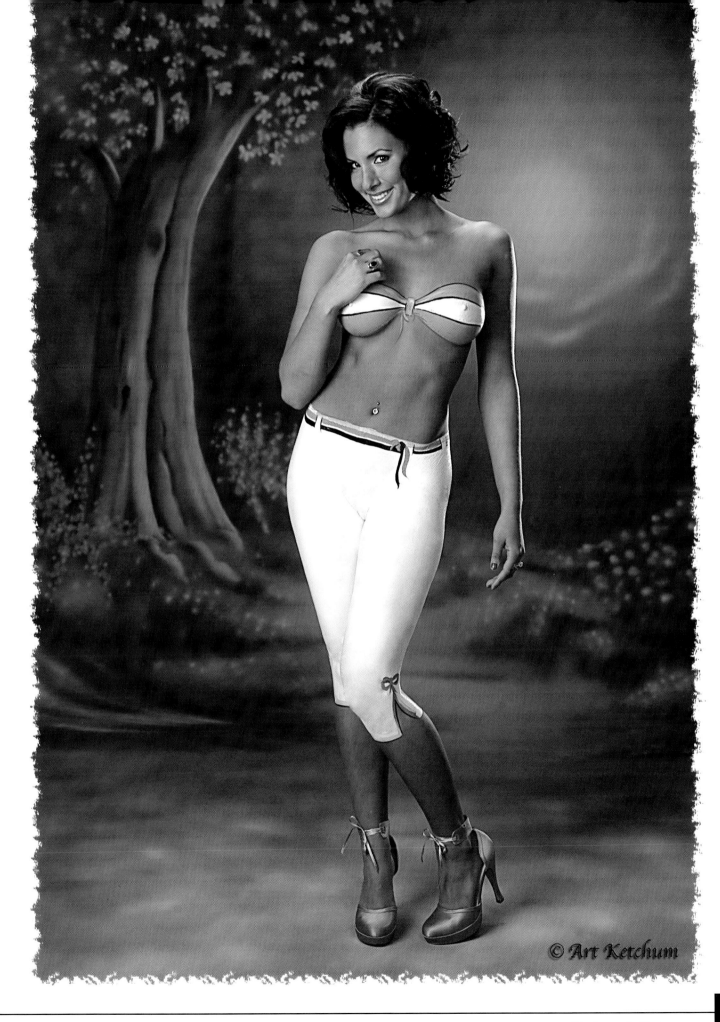

© Art Ketchum

Getting Ready

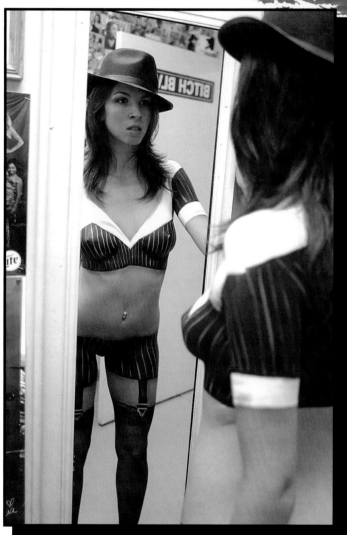

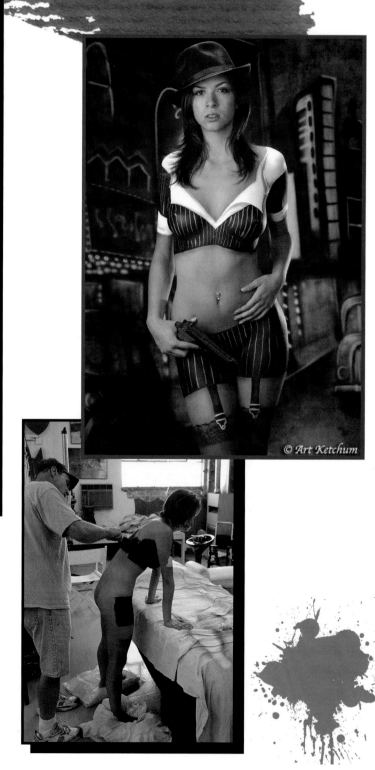

© Art Ketchum

Using an air brush lightly creates the look of sheer items, such as stockings.

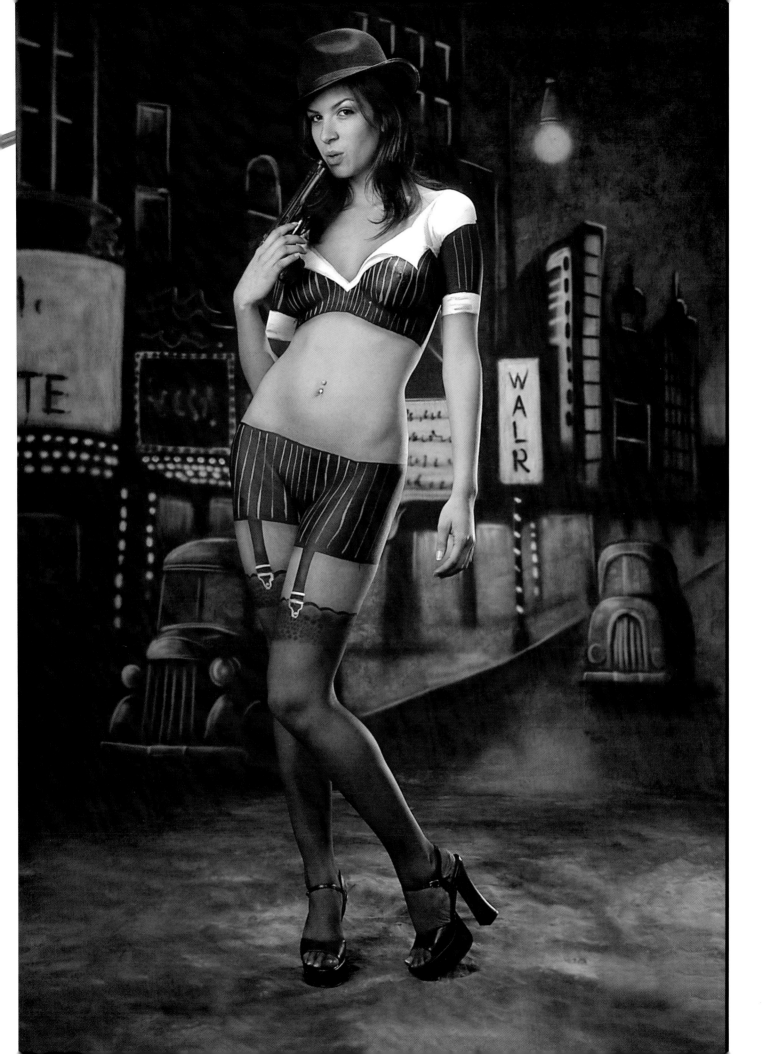

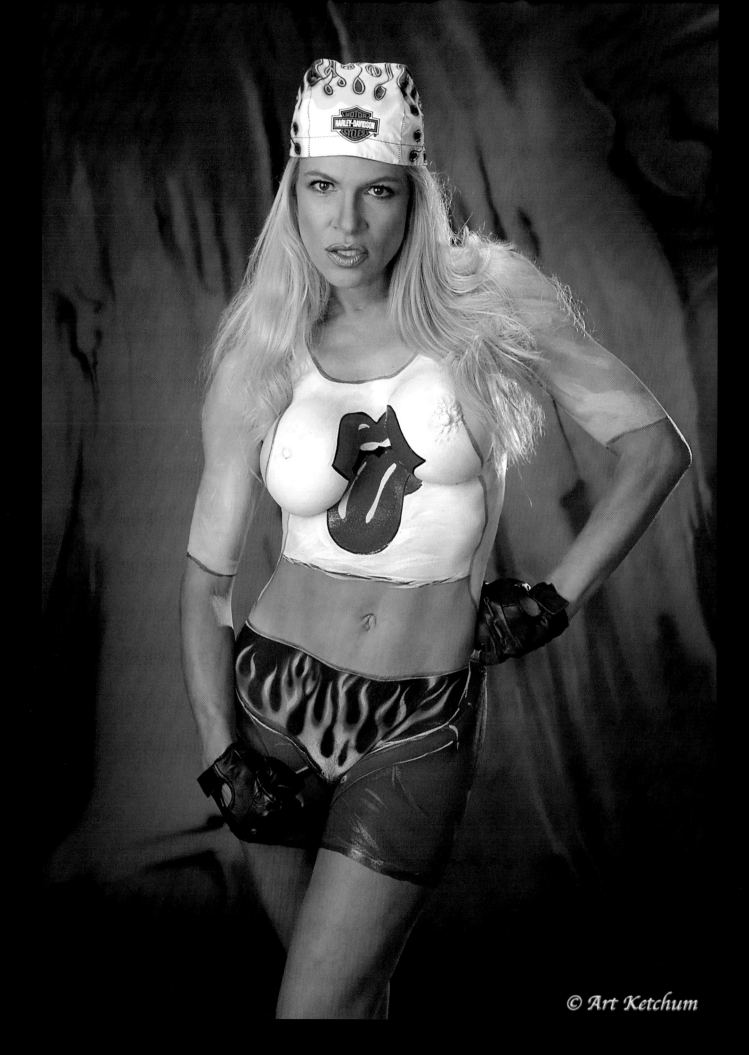

© Art Ketchum

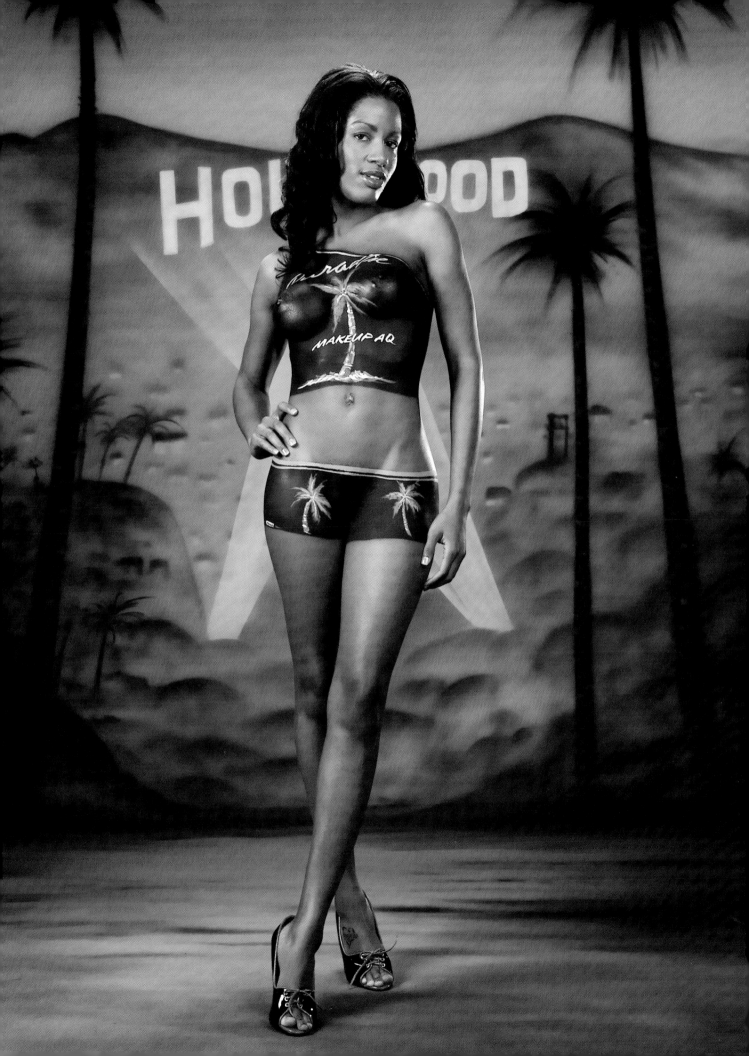

Painting

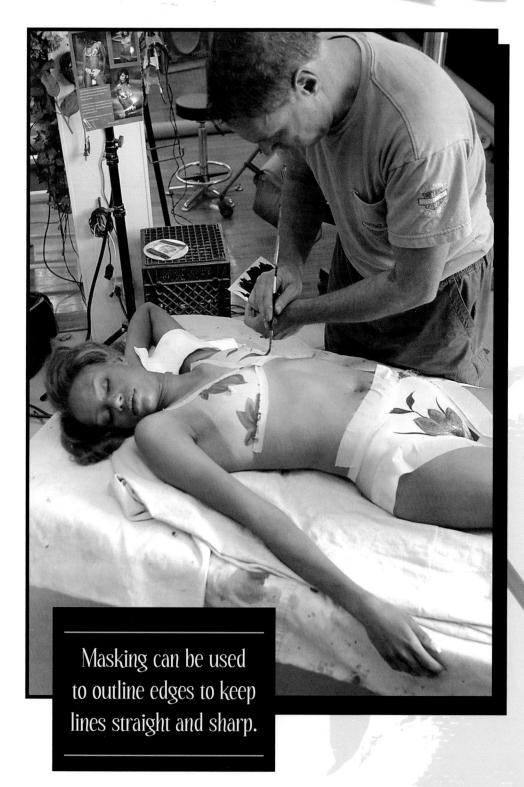

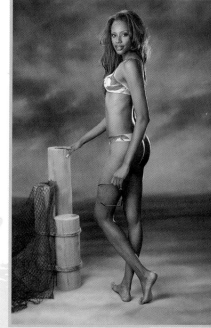

Masking can be used to outline edges to keep lines straight and sharp.

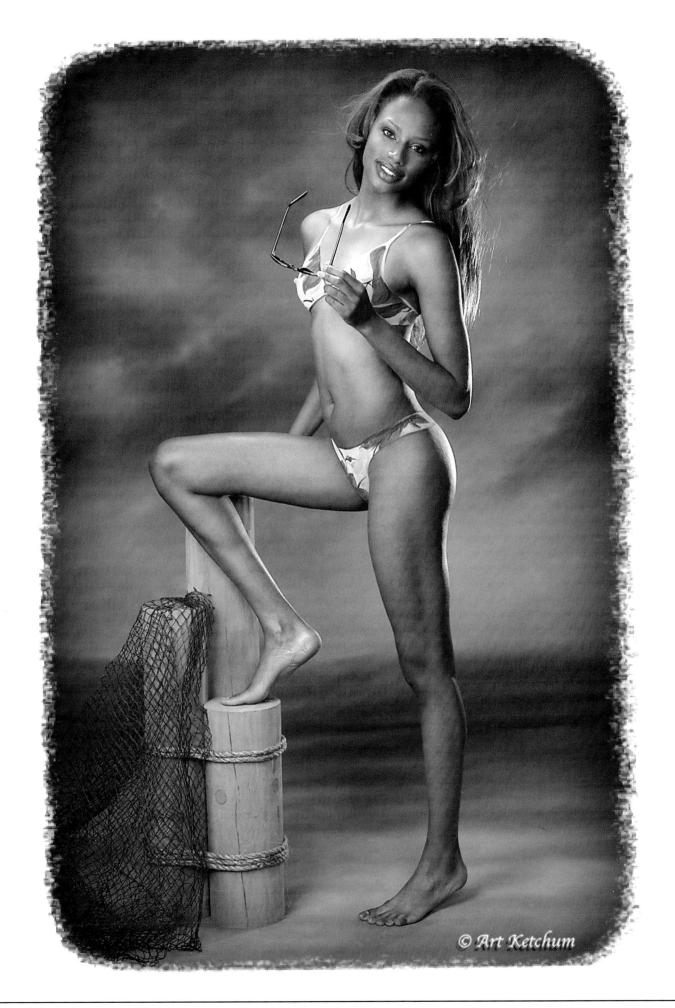

© Art Ketchum

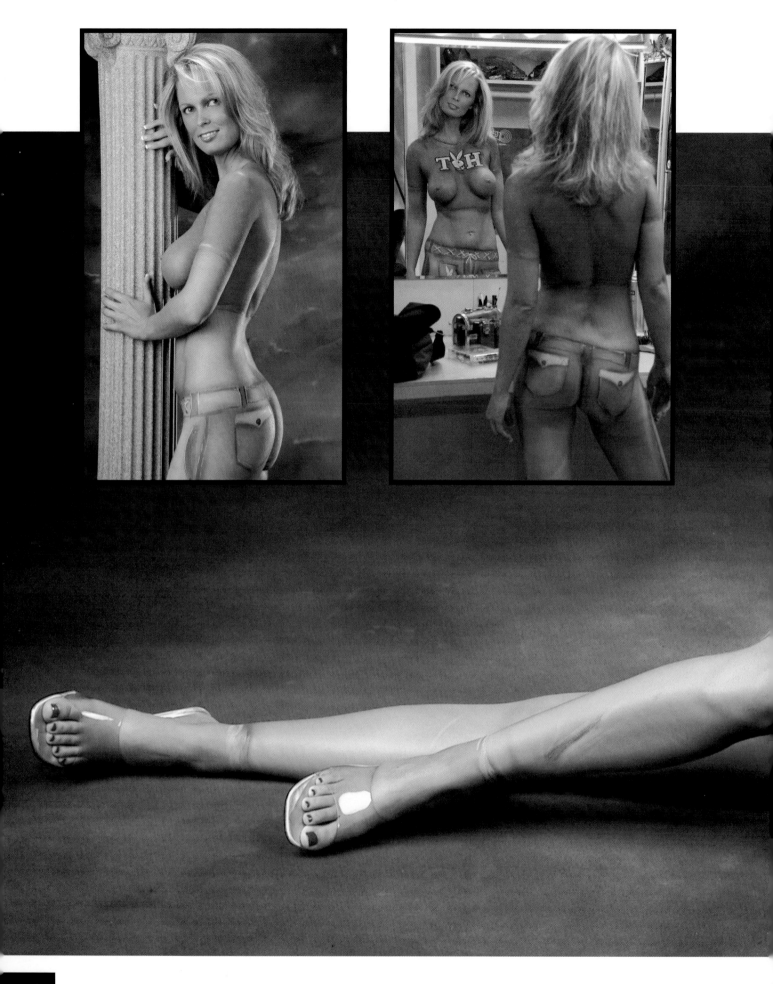

Painting the Body Beautiful

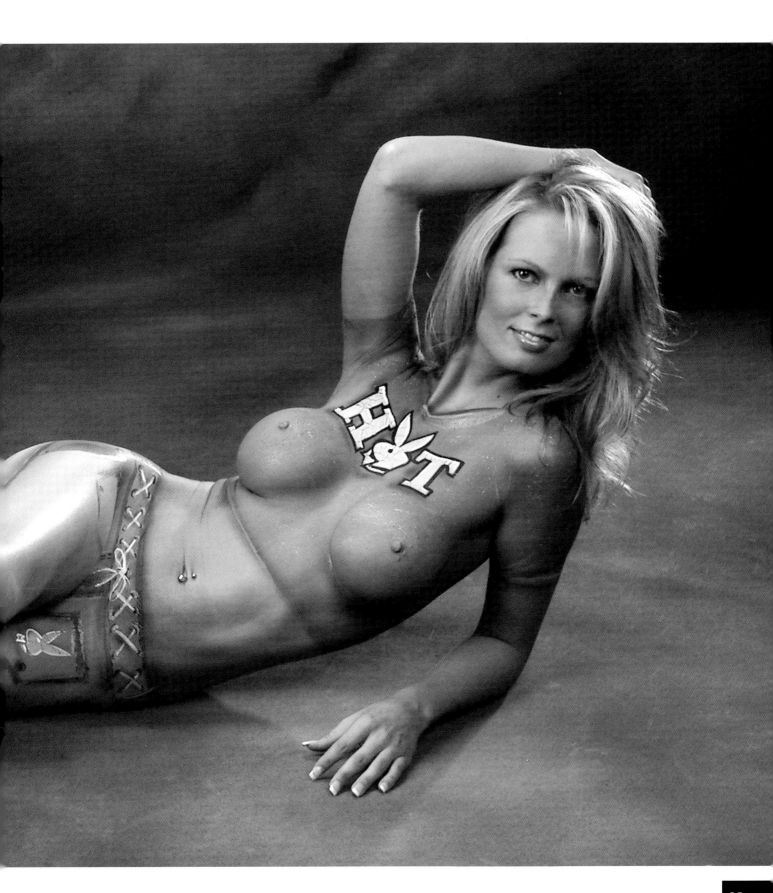

Getting Ready

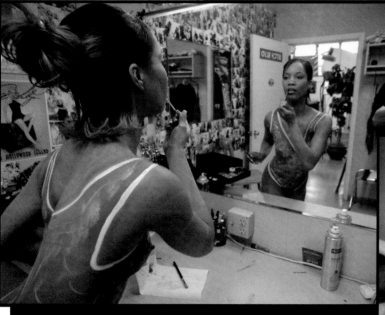

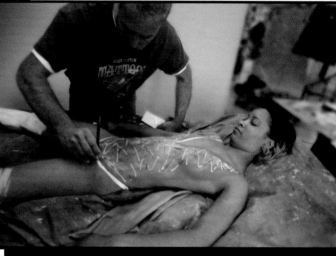

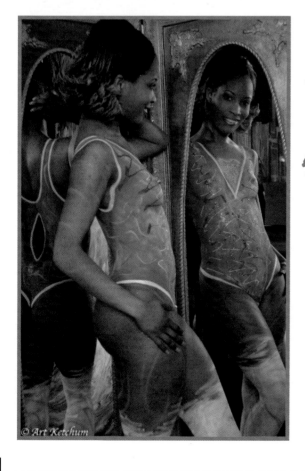

© Art Ketchum

Brando uses both opaque and translucent paint to achieve the effect of clothing.

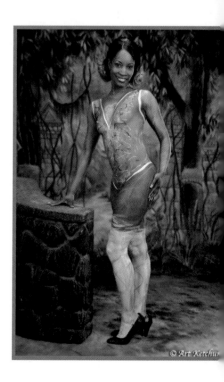

© Art Ketchum

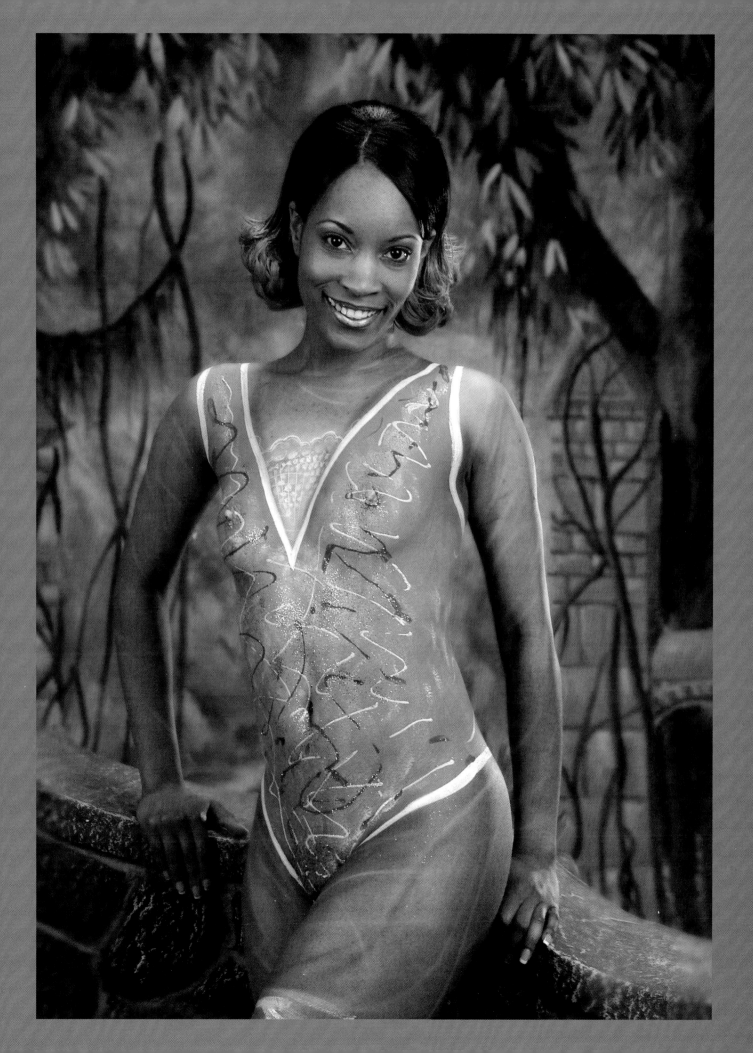

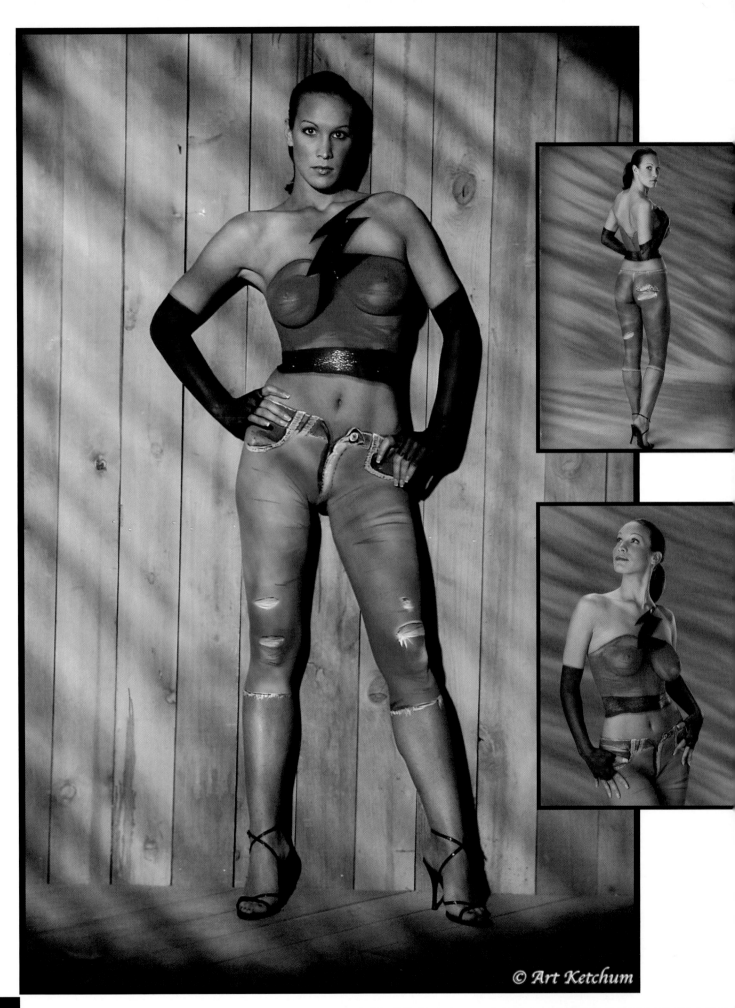

© Art Ketchum

Painting the Body Beautiful

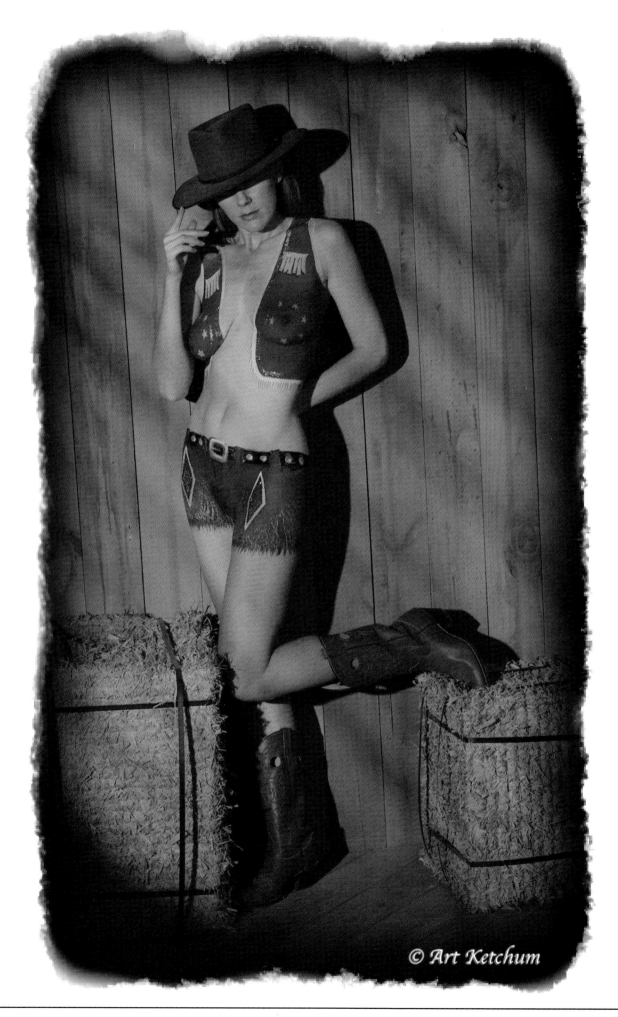

© Art Ketchum

The Process

Barrier spray fixer and sealer is used once the painting is complete so it won't smear or run while being photographed.

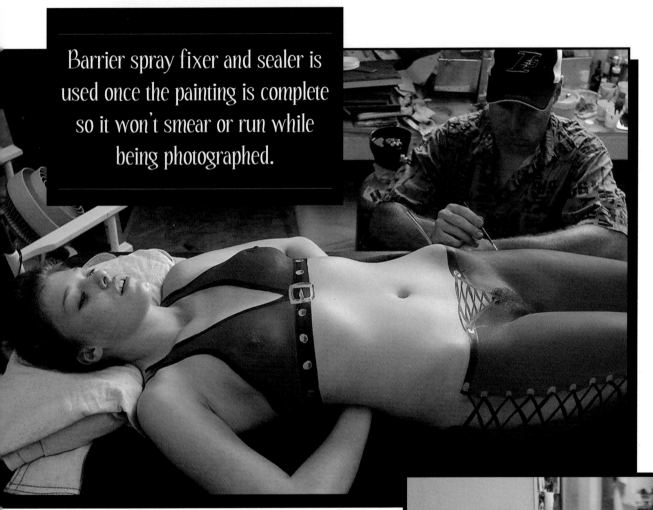

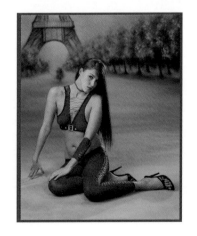

© Art Ketchum

Painting the Body Beautiful

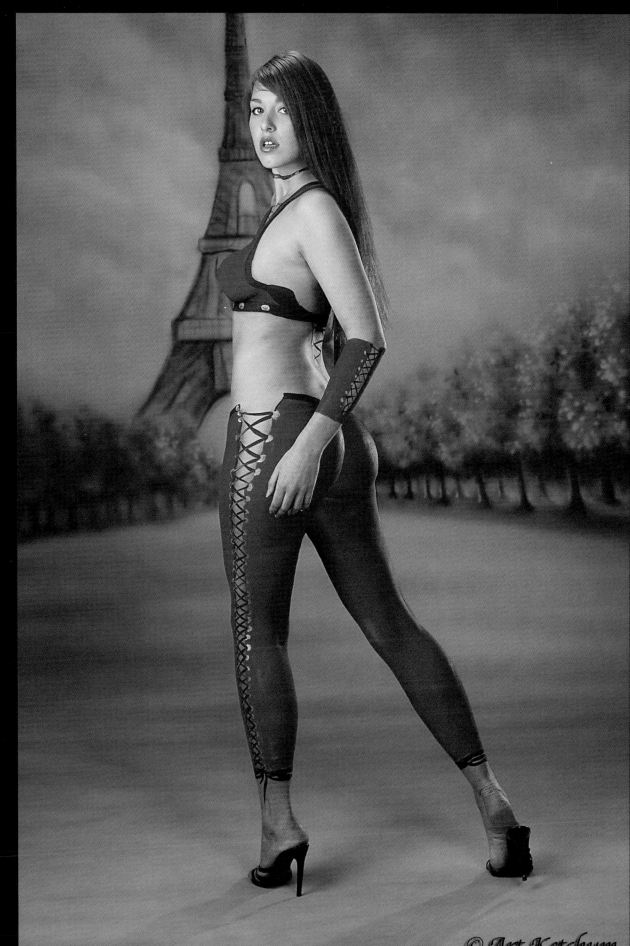

© Art Ketchum

Preparation

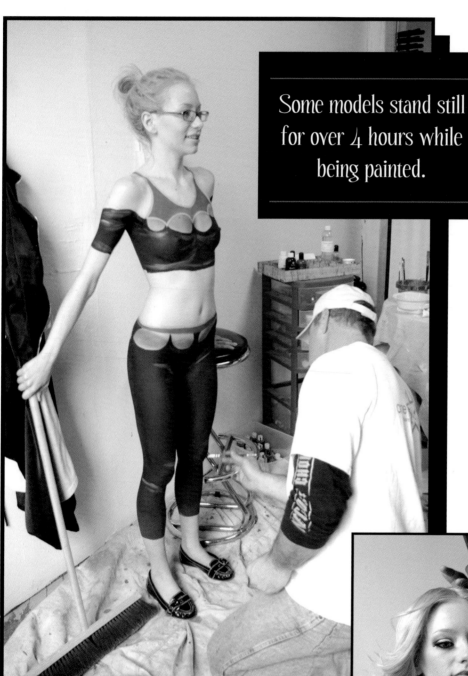

Some models stand still for over 4 hours while being painted.

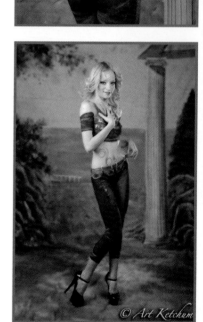

© Art Ketchum

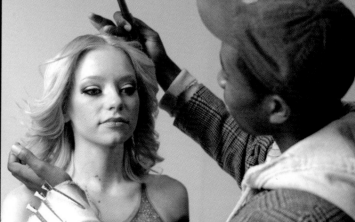

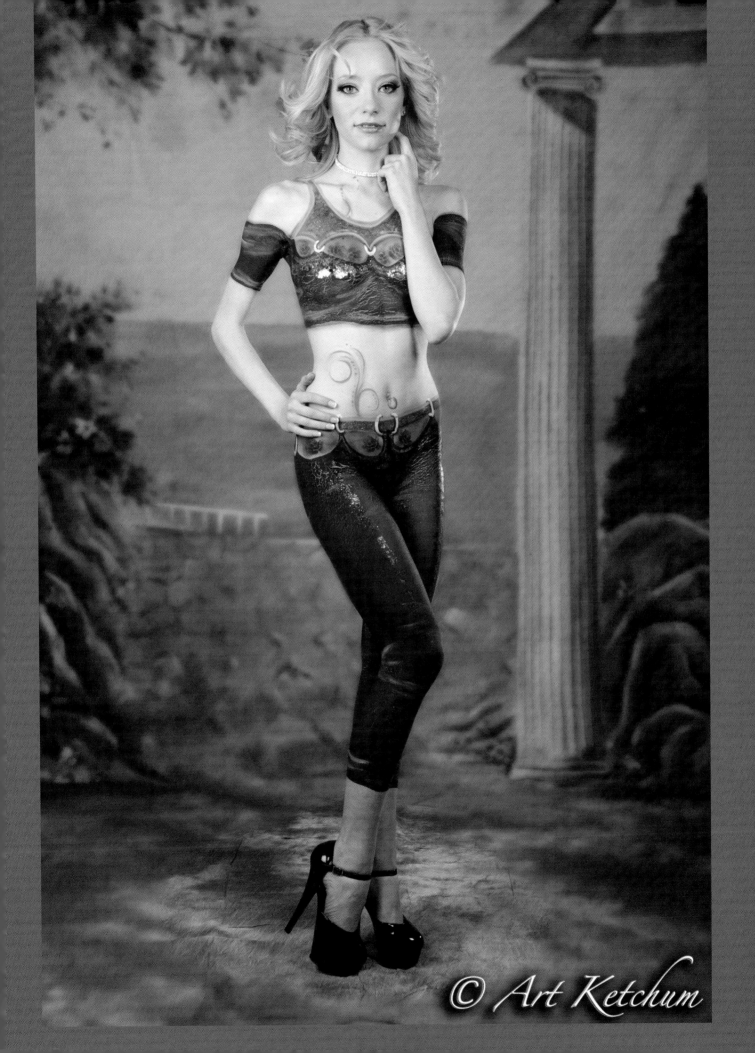

© Art Ketchum

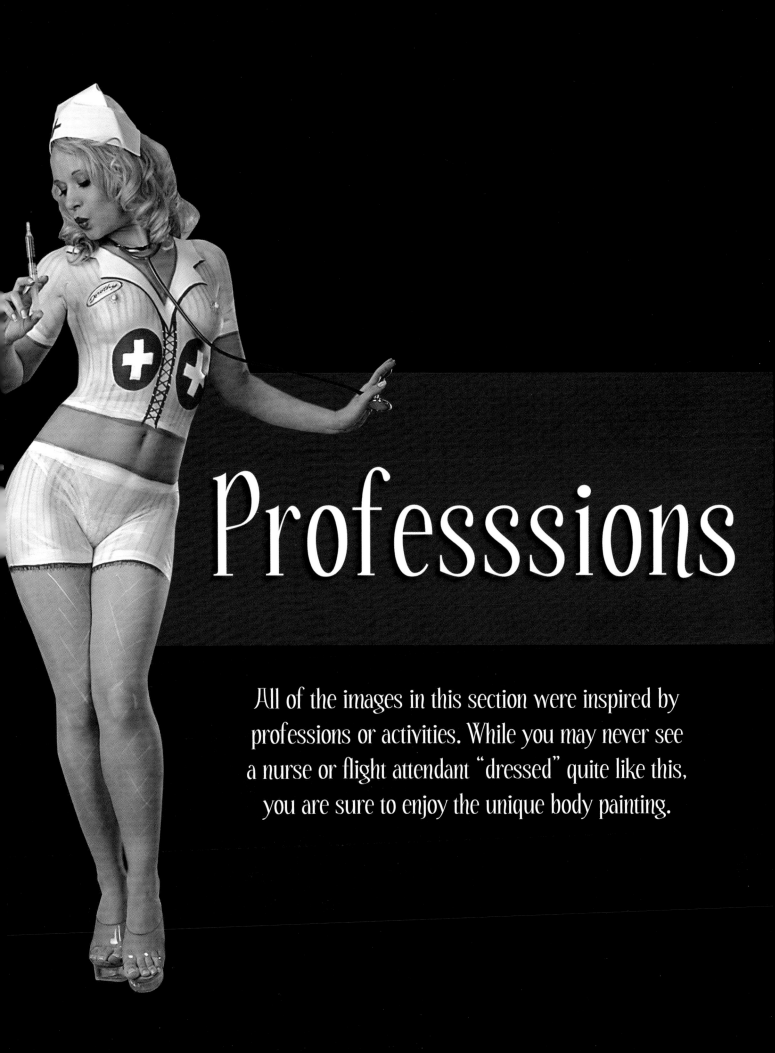

Professsions

All of the images in this section were inspired by
professions or activities. While you may never see
a nurse or flight attendant "dressed" quite like this,
you are sure to enjoy the unique body painting.

Boxer

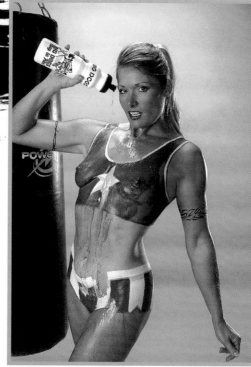

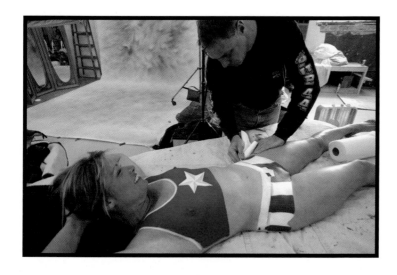

The paints used are water soluble and remove easily with soap and water.

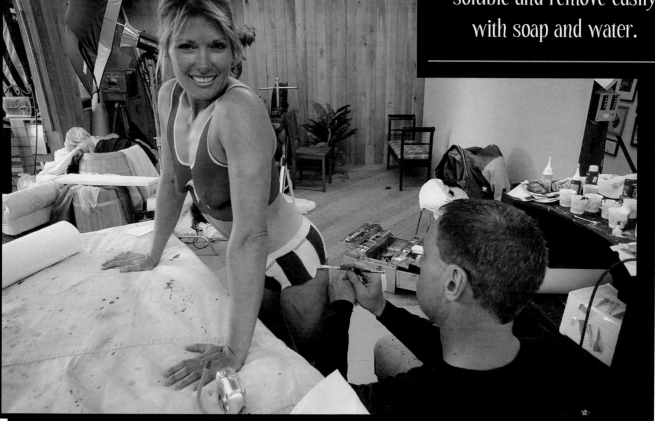

Painting the Body Beautiful

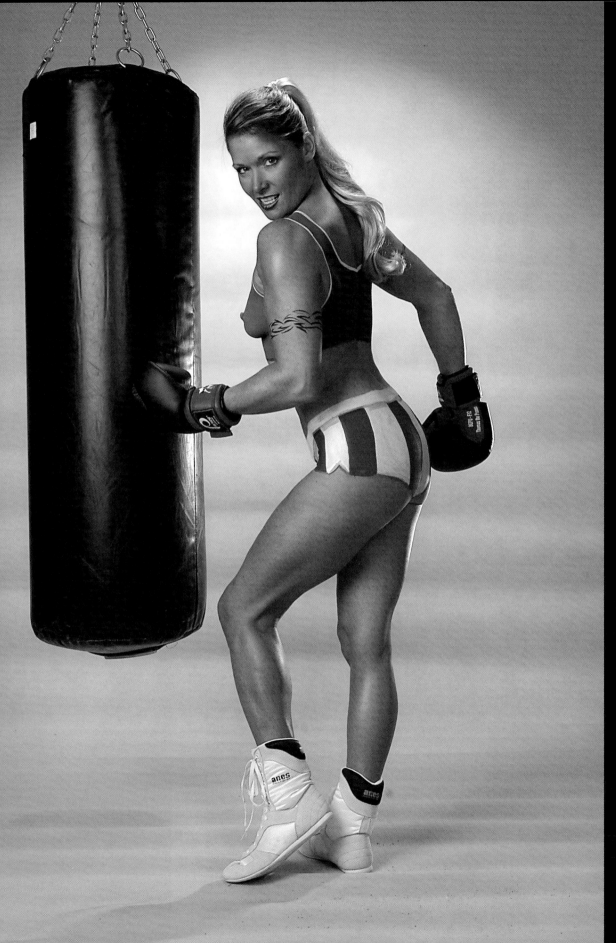

Bicyclist

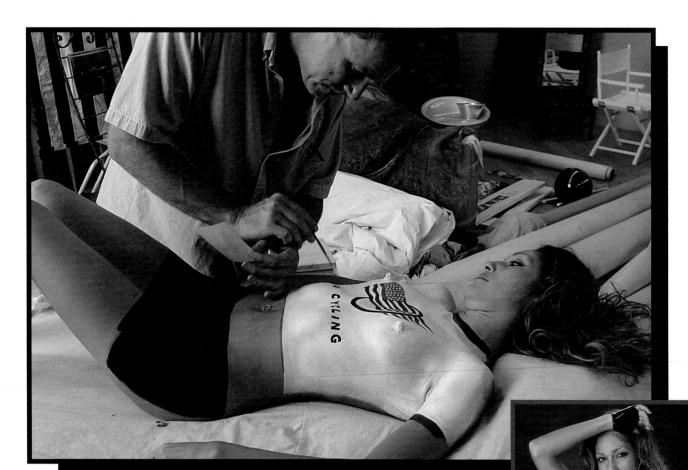

Mehron Barrier Spray Fixer and Sealer is applied as a primer for application of the paint.

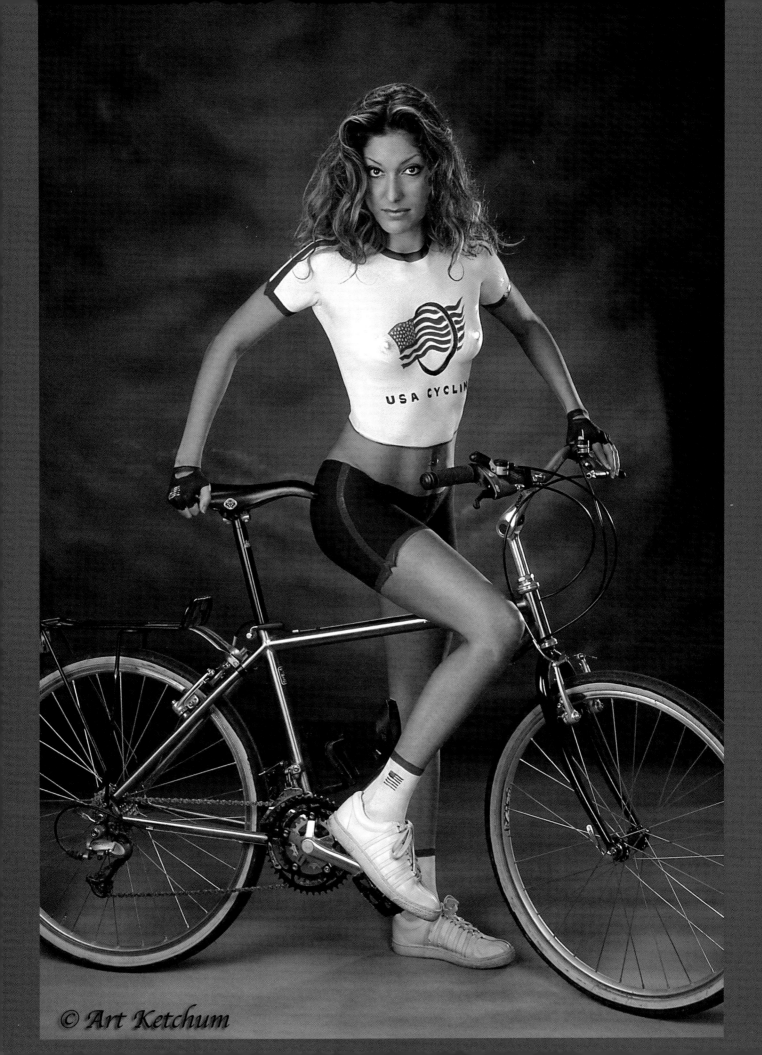

© Art Ketchum

Lifeguard

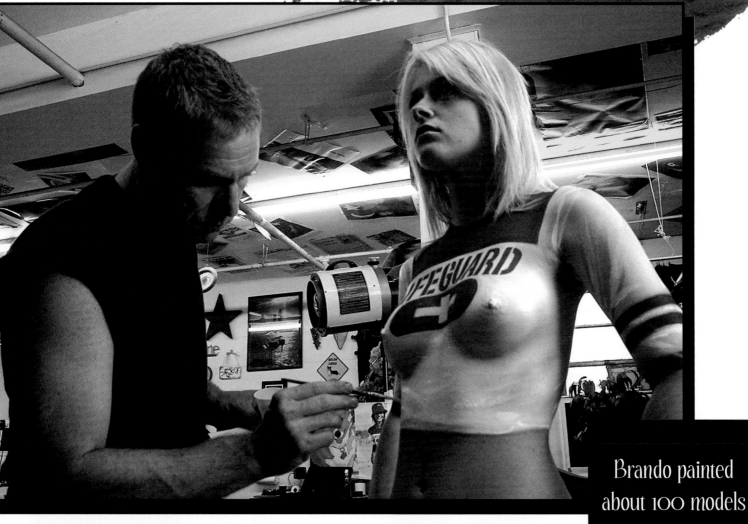

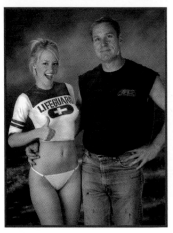

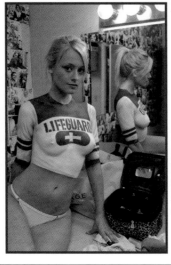

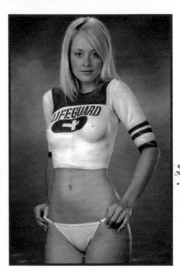

Brando painted about 100 models over a 3-year period for Art Ketchum to photograph.

Painting the Body Beautiful

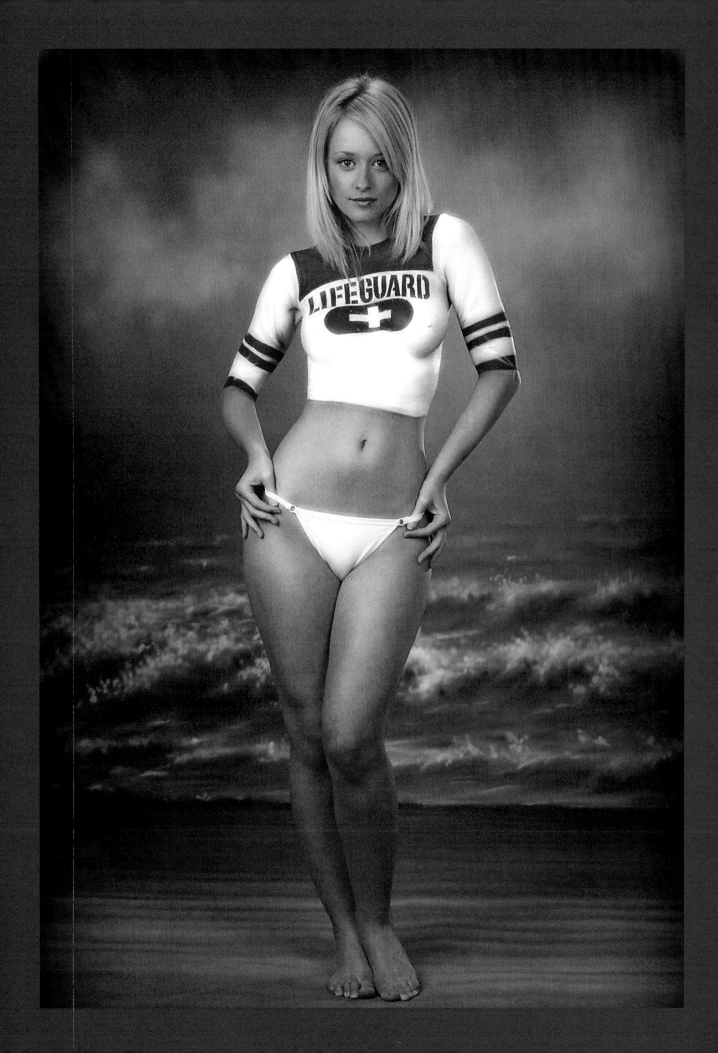

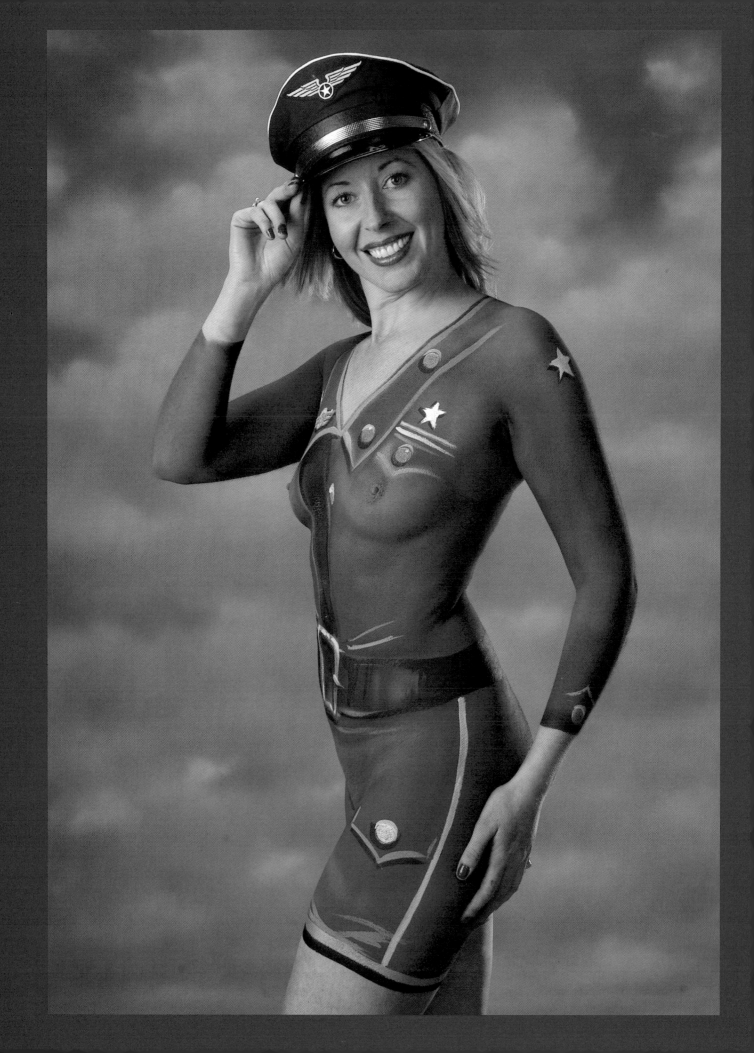

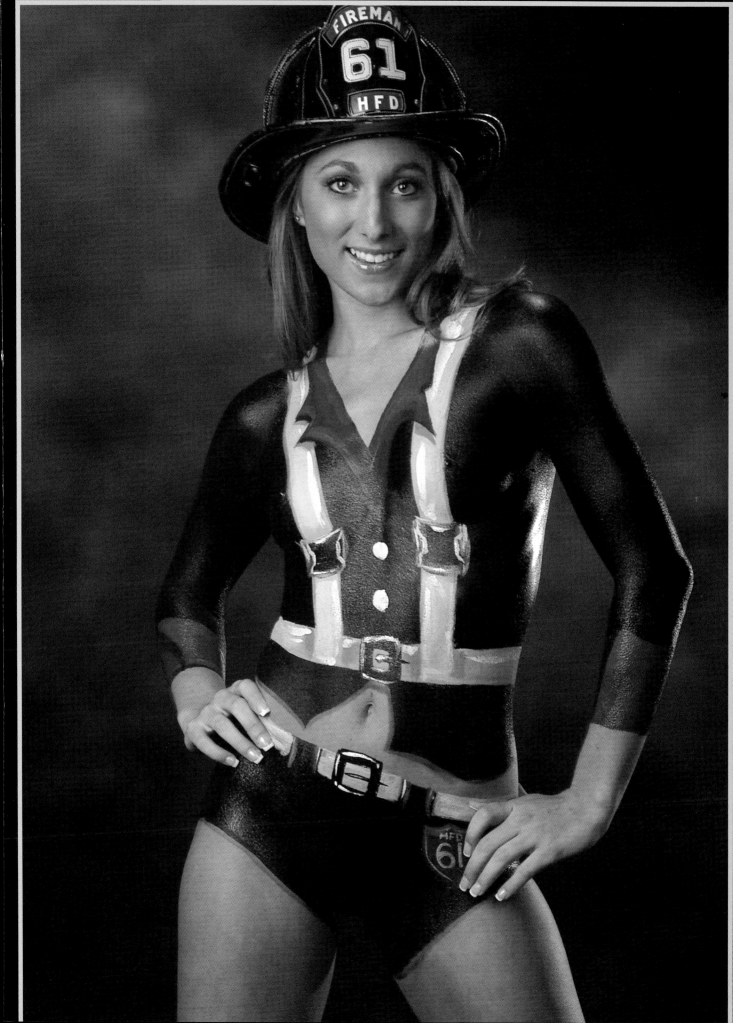

Nurse

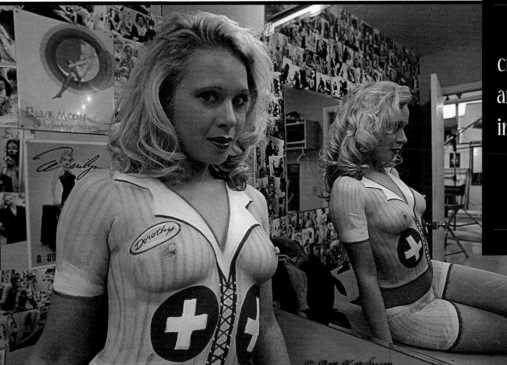

© Art Ketchum

"Body painting is a creative art in which the artist and model become intertwined in a work of fantasy and color."

– Dorothy, model

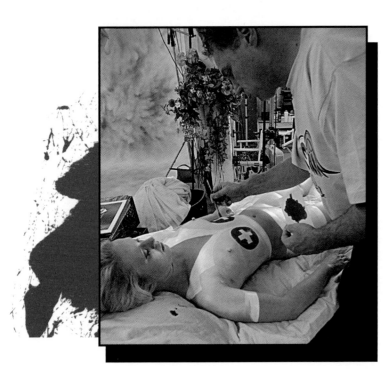

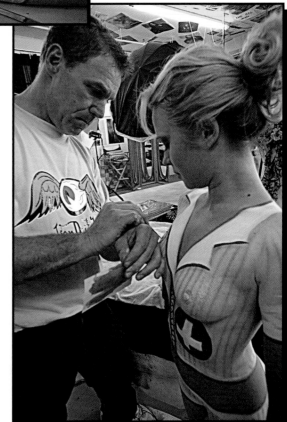

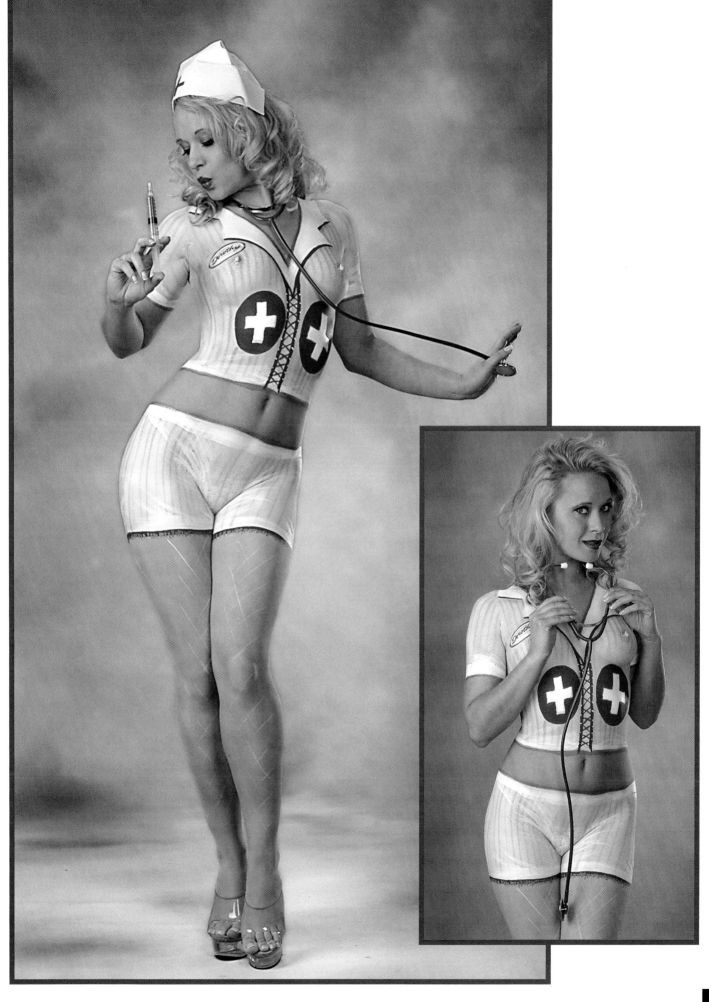

Sailor

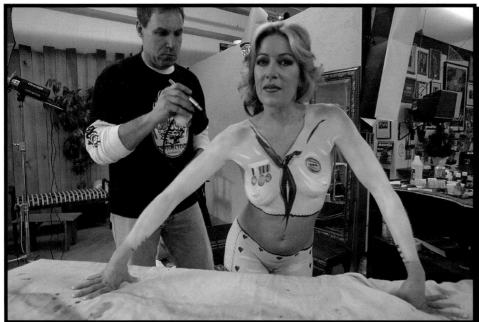

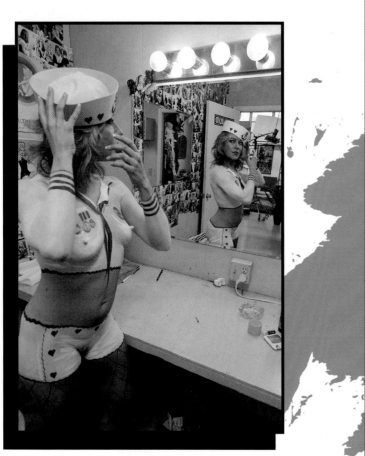

Many of these images were inspired by pin-up calendars from the 1940s and '50s.

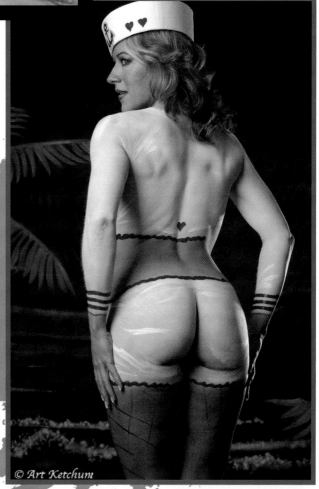

© Art Ketchum

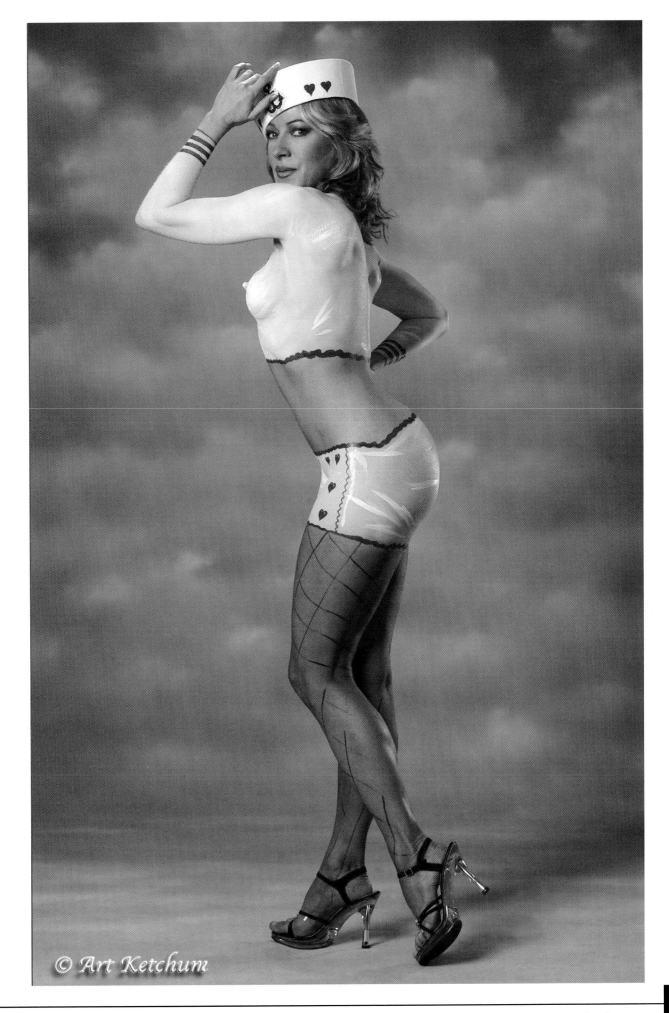

© Art Ketchum

Pit Crew

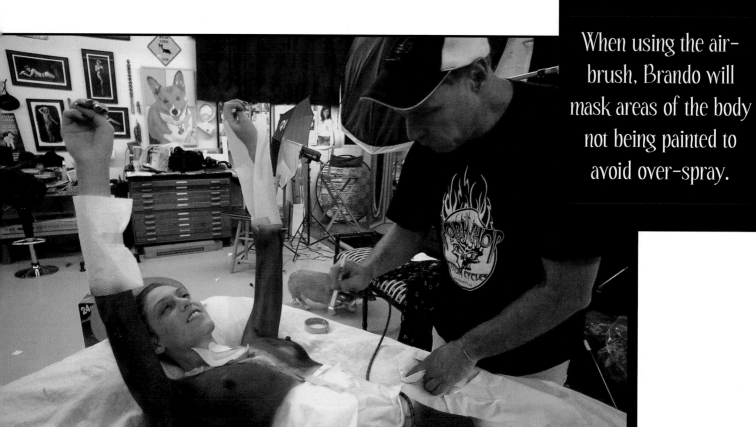

When using the air-brush, Brando will mask areas of the body not being painted to avoid over-spray.

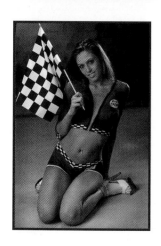

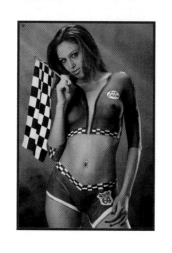

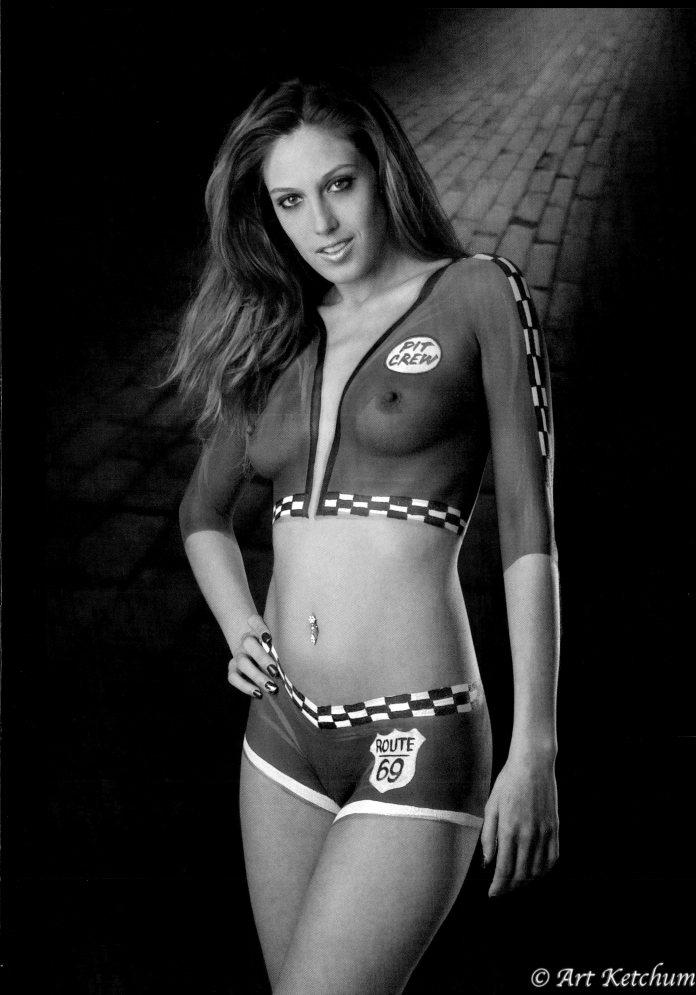

© Art Ketchum

Tennis Player

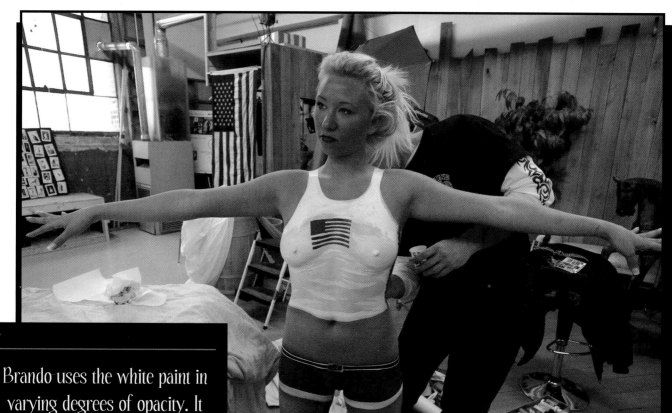

Brando uses the white paint in varying degrees of opacity. It gives the appearance of the shirt sticking to the model's body.

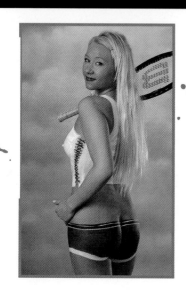

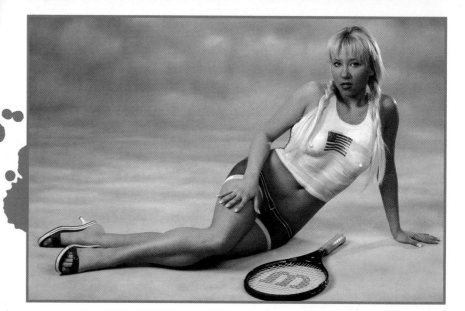

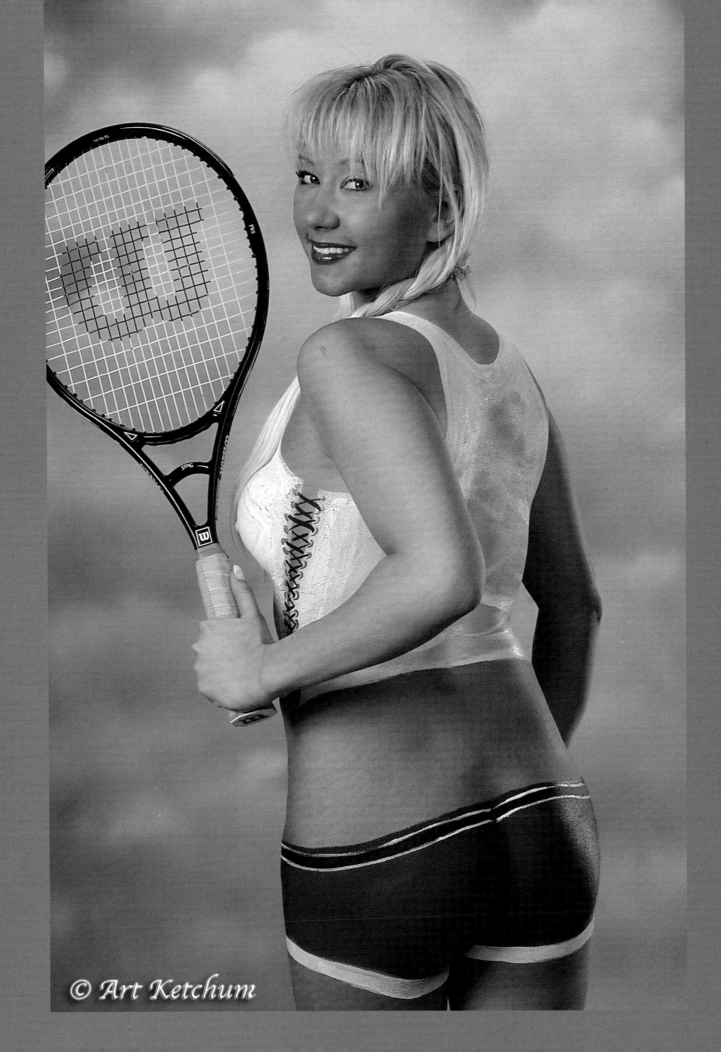

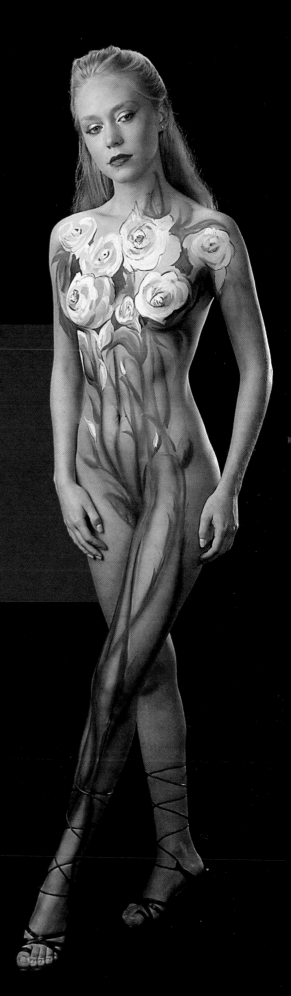

Fantasy
& Florals

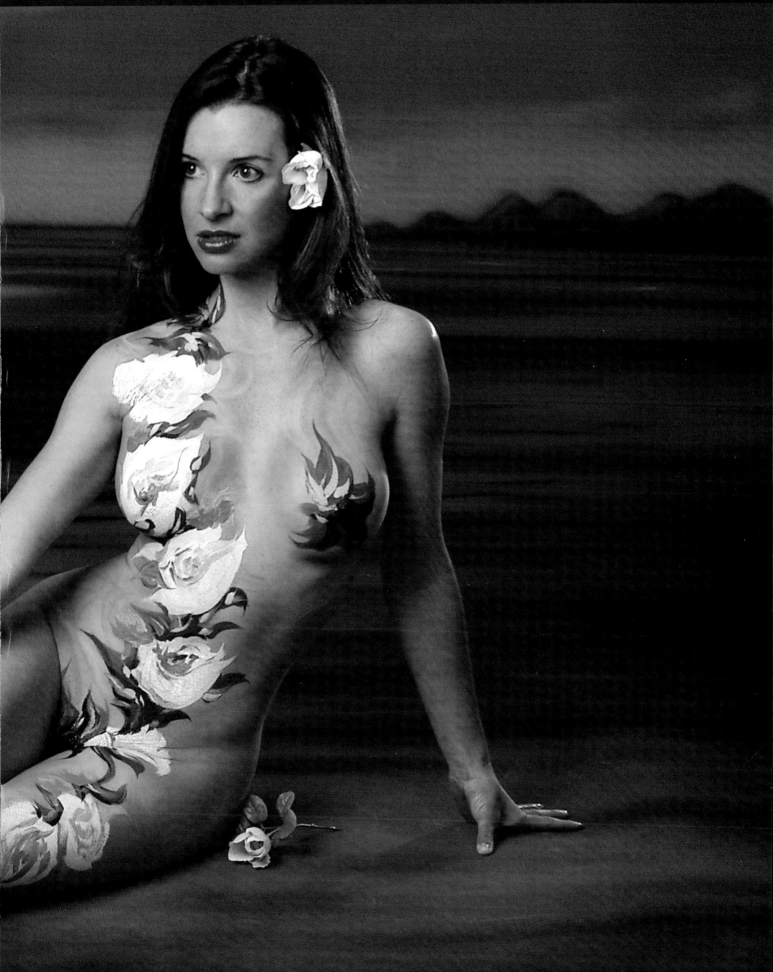

Painting

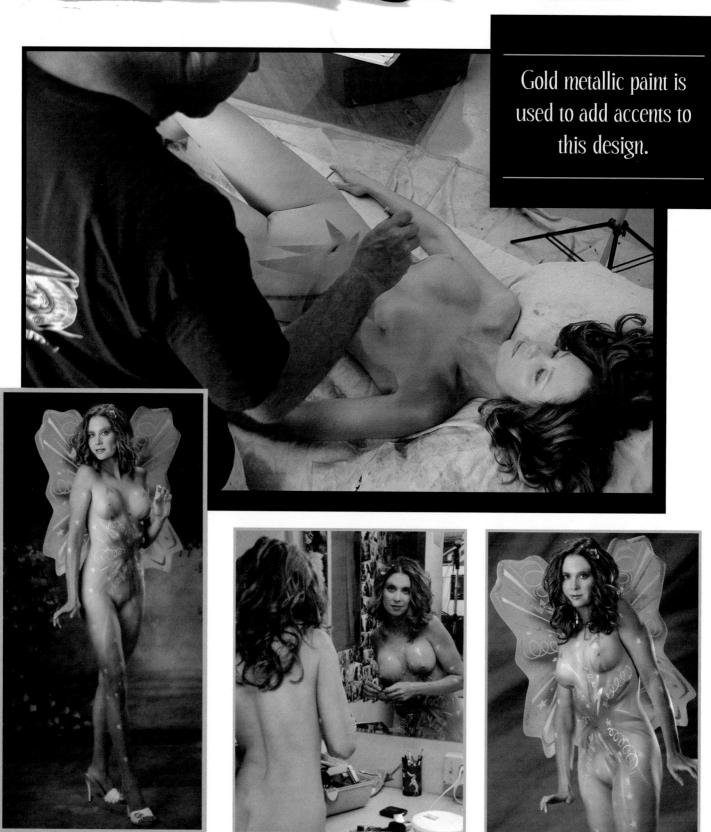

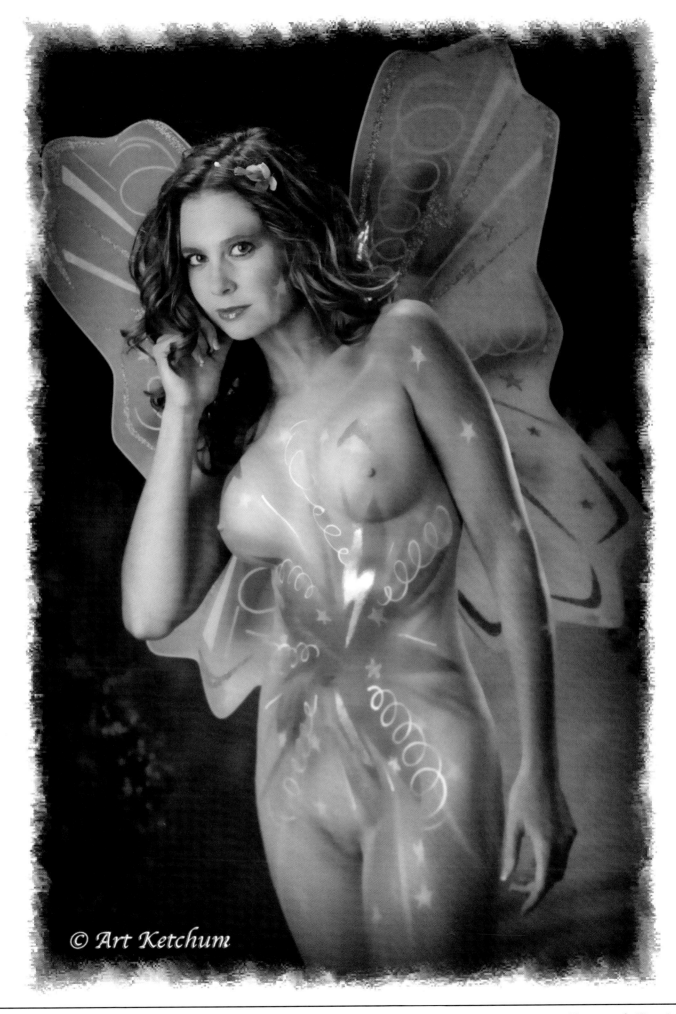

© Art Ketchum

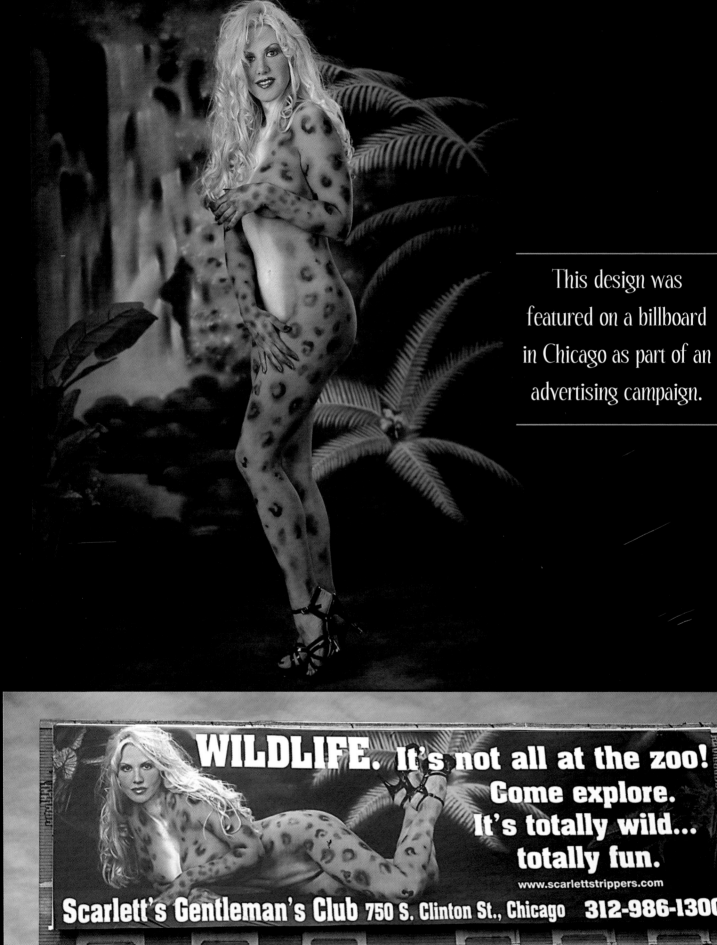

This design was featured on a billboard in Chicago as part of an advertising campaign.

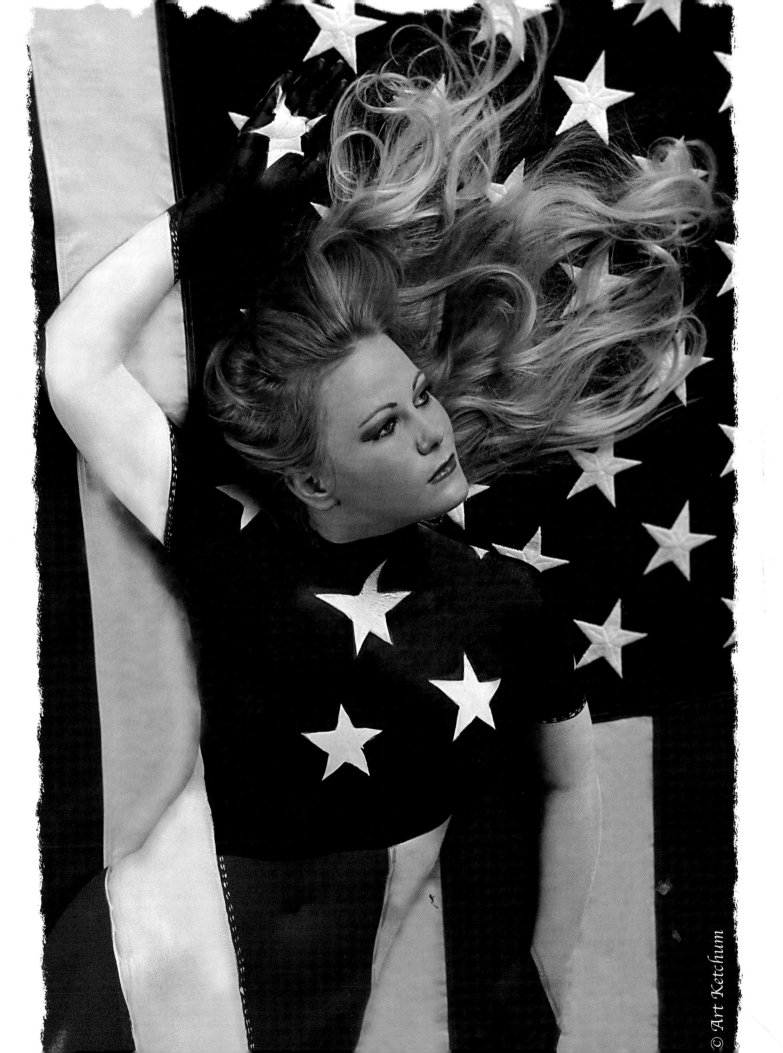

The Process

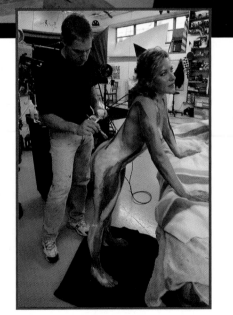

This colorful abstract design was inspired by the 1966 movie "The Swinger" starring Ann Margaret.

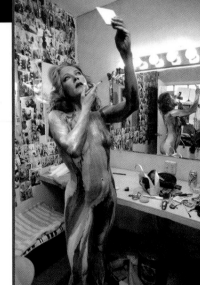

Painting the Body Beautiful

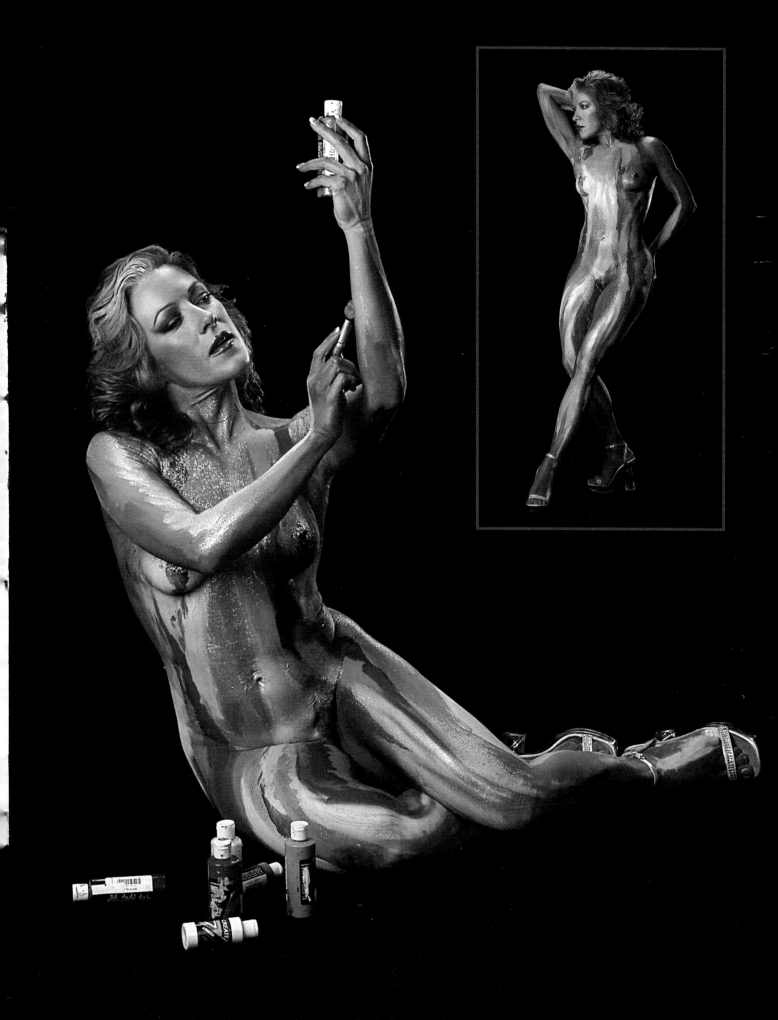

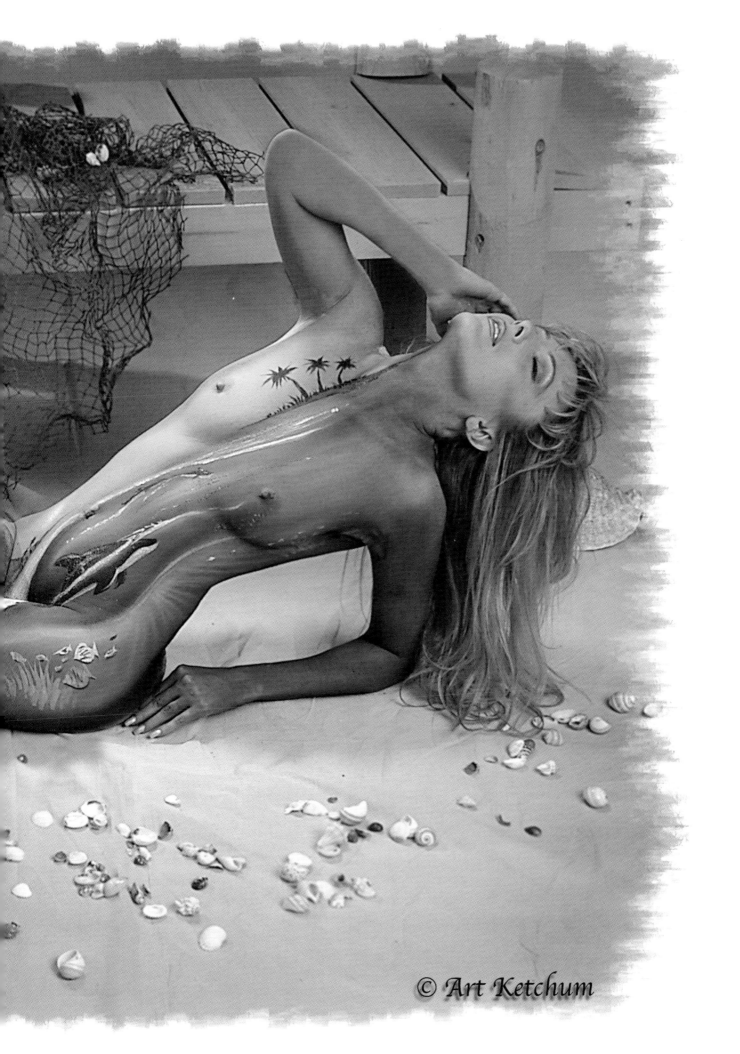

© Art Ketchum

Masquerade

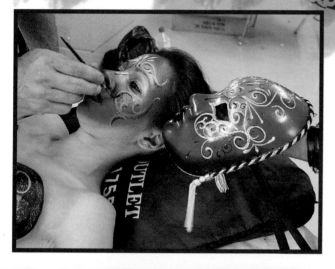

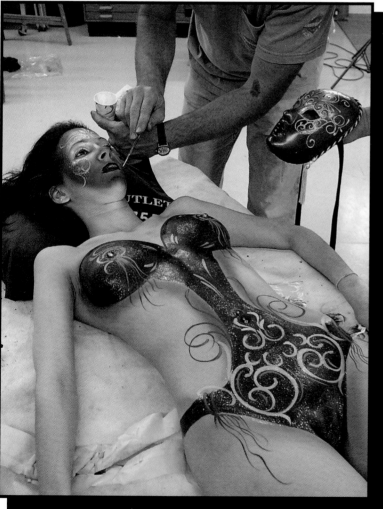

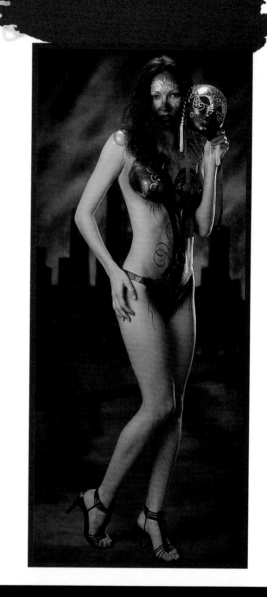

This masquerade design features elaborate face painting, which obscures the division between reality and illusion.

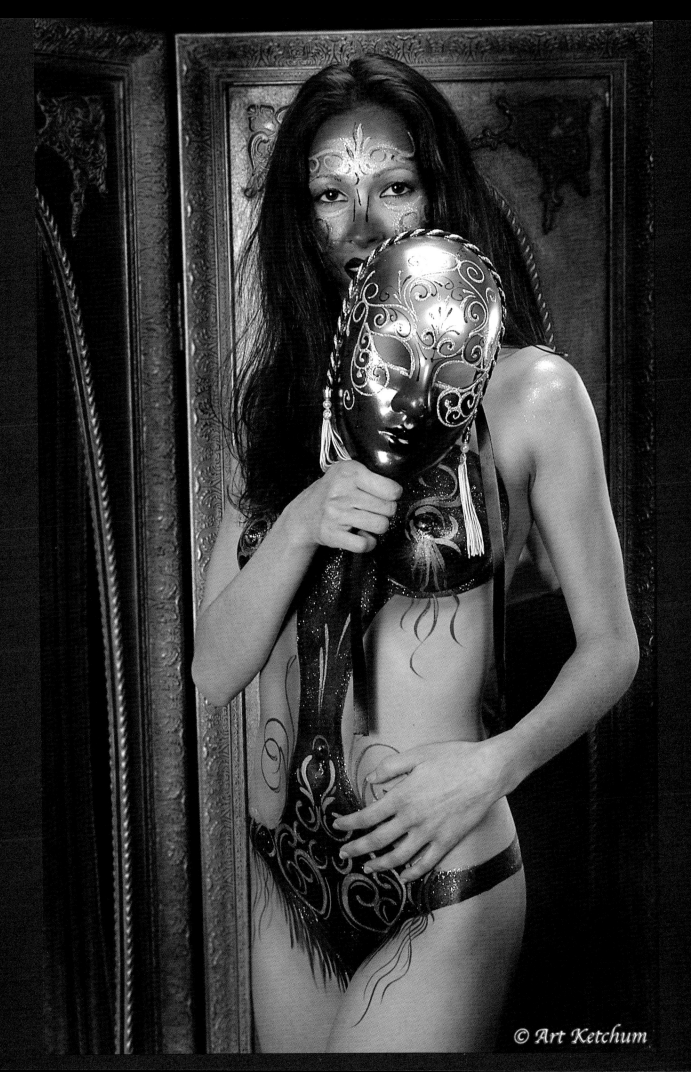

© Art Ketchum

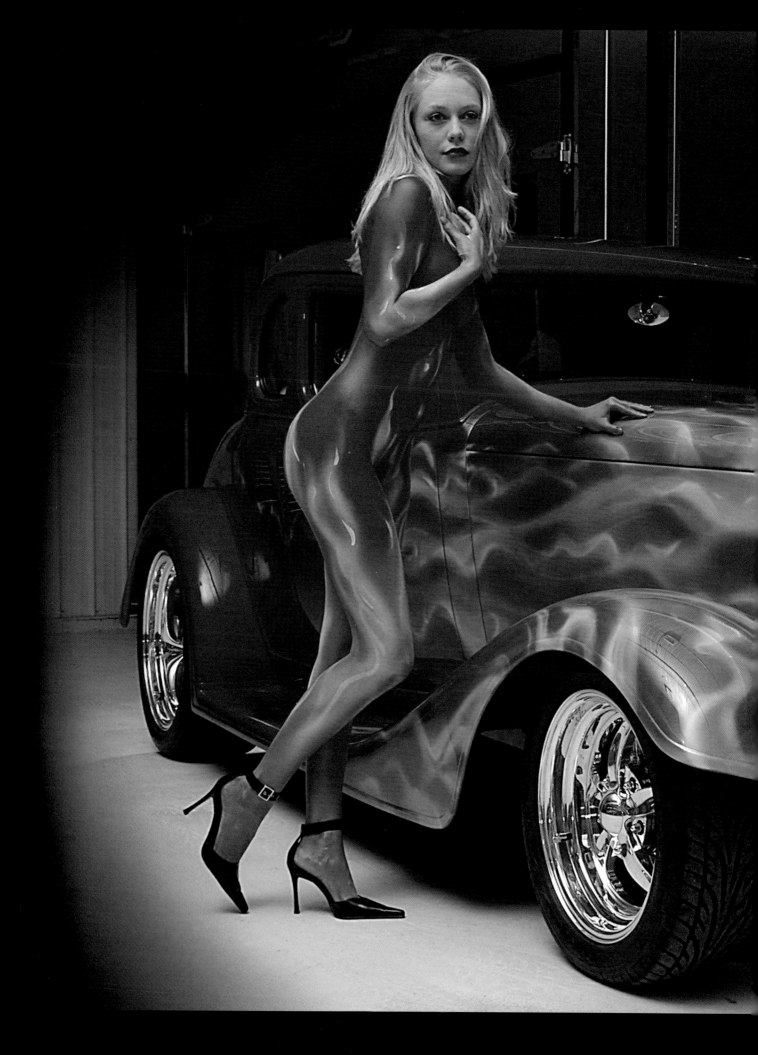

Unicorn

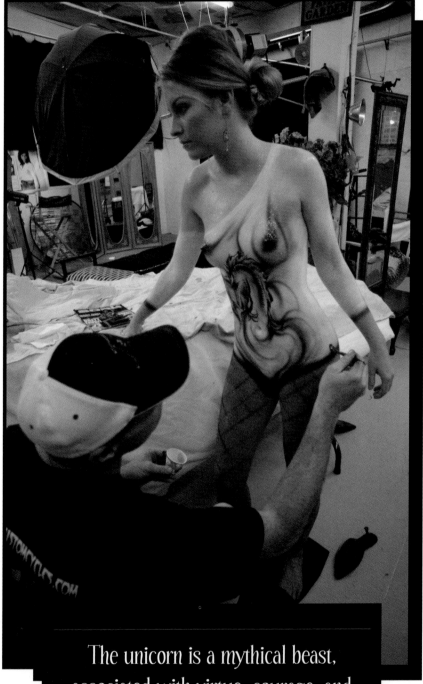

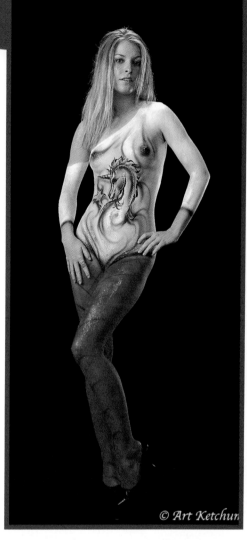

© Art Ketchum

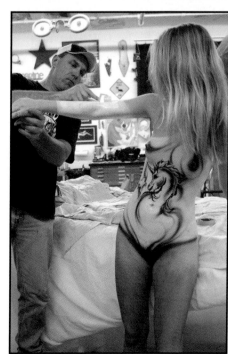

The unicorn is a mythical beast, associated with virtue, courage, and strength. Unicorns also symbolize purity, elegance, and charm.

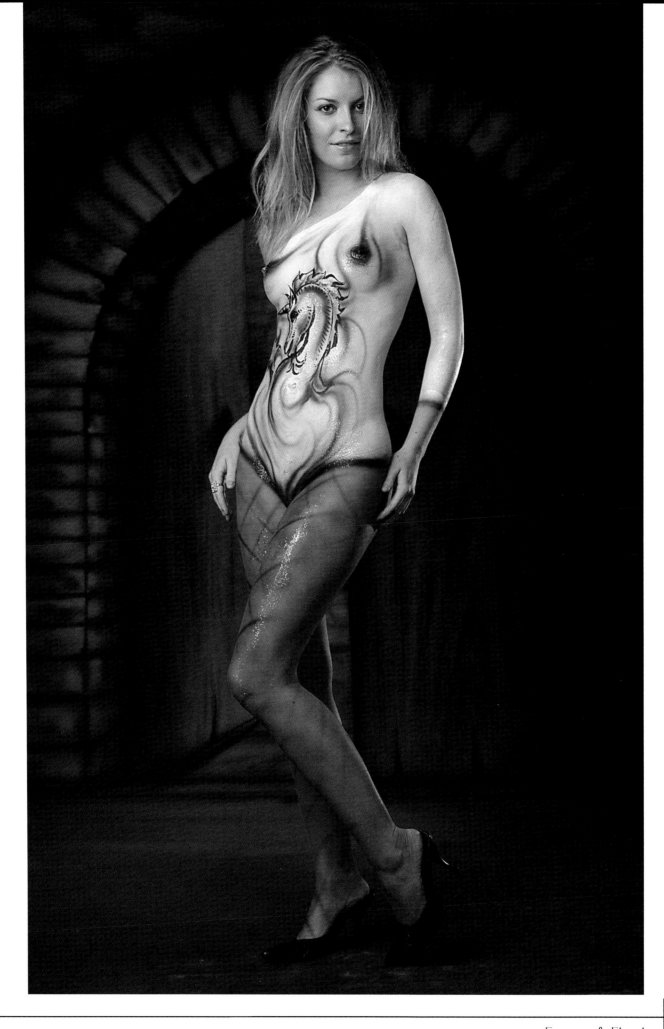

Fantasy & Florals

Floral

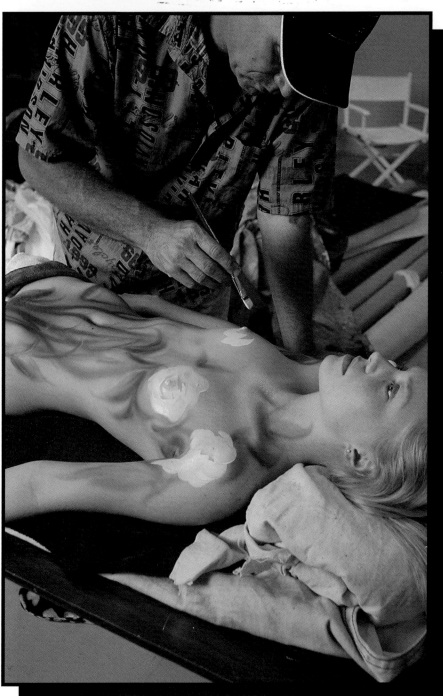

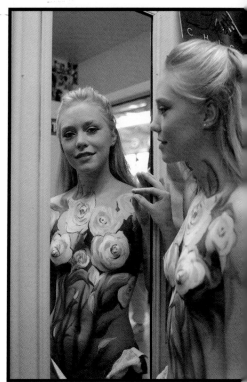

The bright yellow in this floral design was coordinated to enhance the skin tone and coloring of the model.

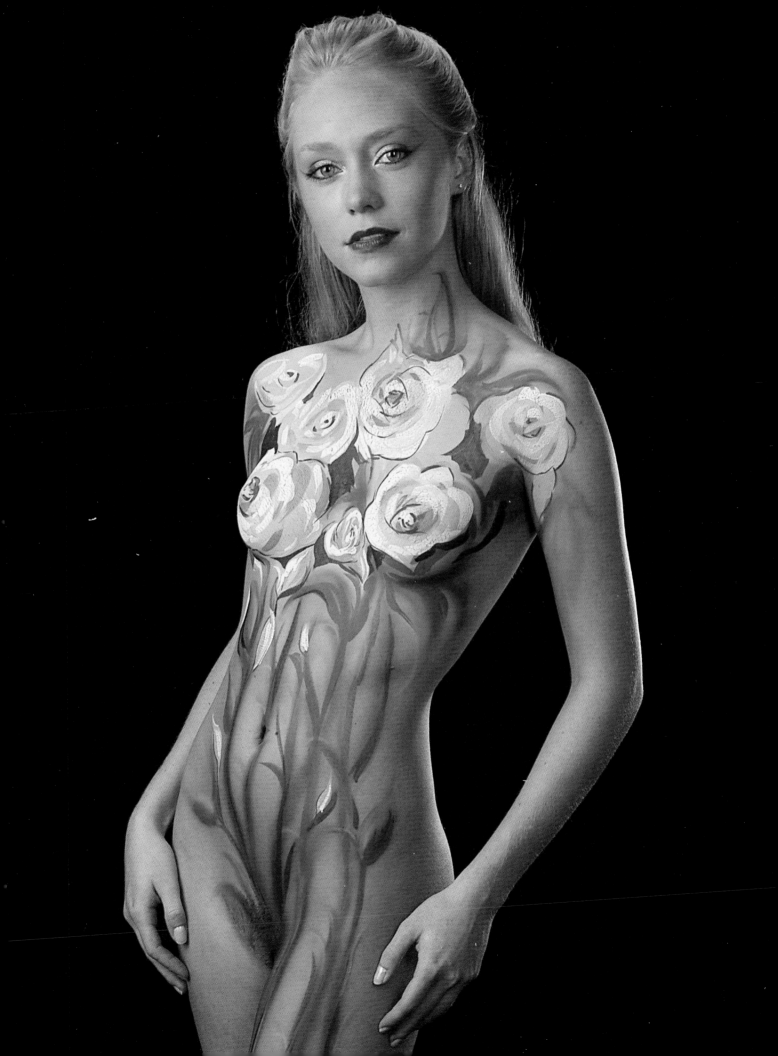

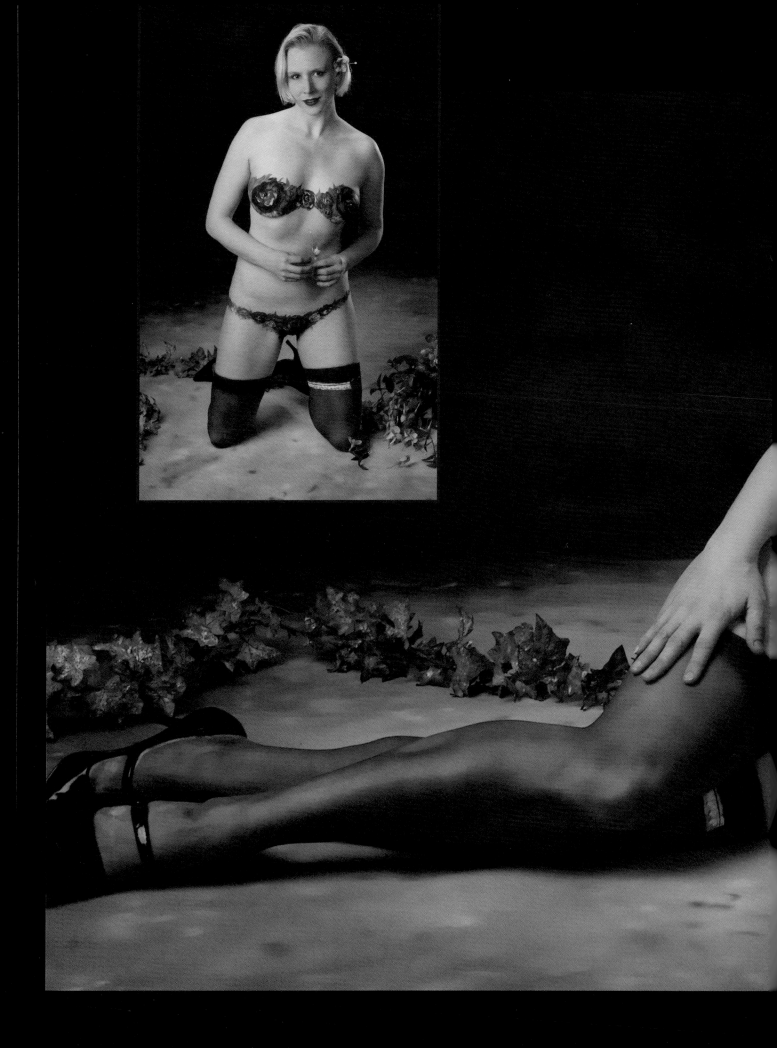

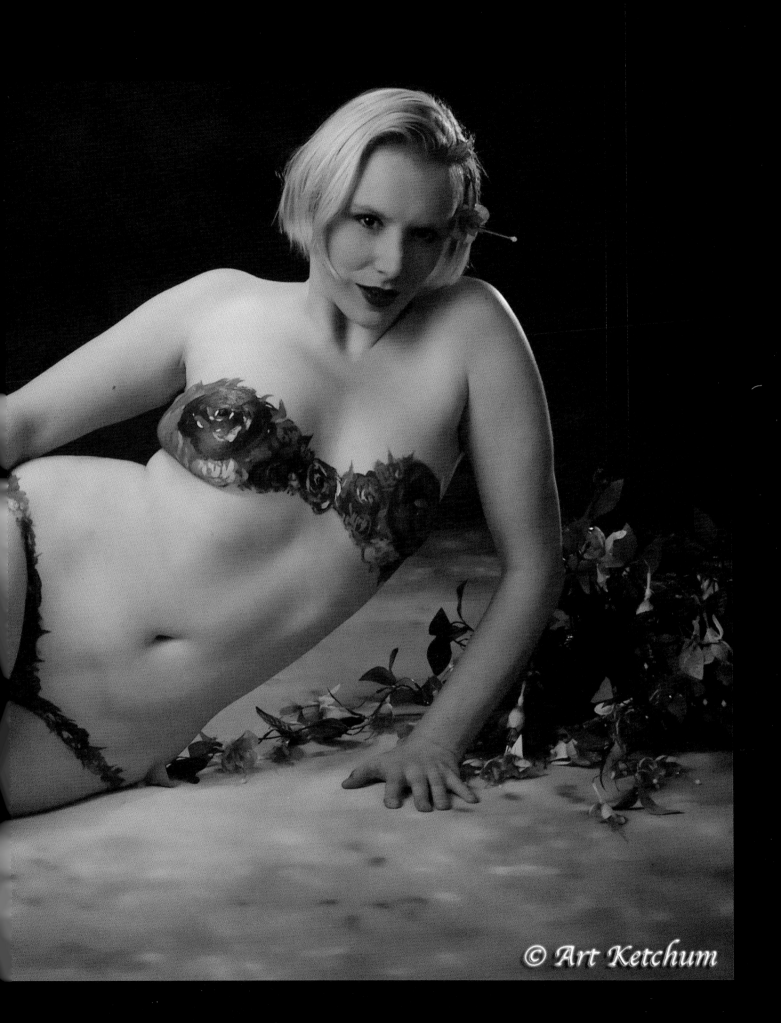

© Art Ketchum

Lingerie

Getting Ready

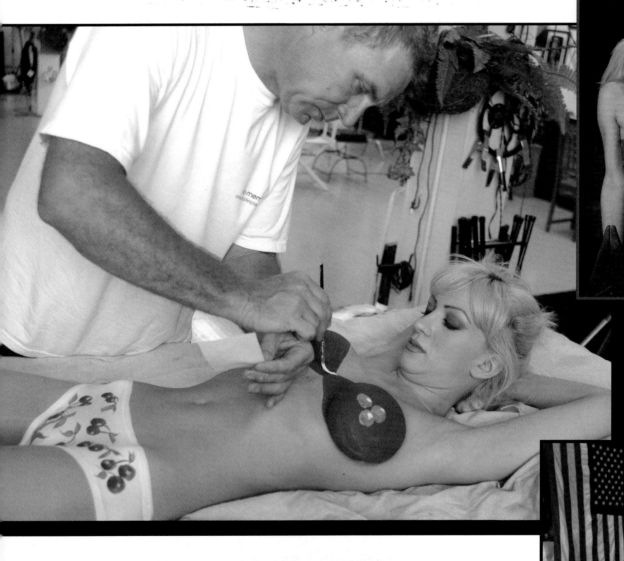

The intricate designs and lace detailing on lingerie require extra time and patience for both the model and Brando.

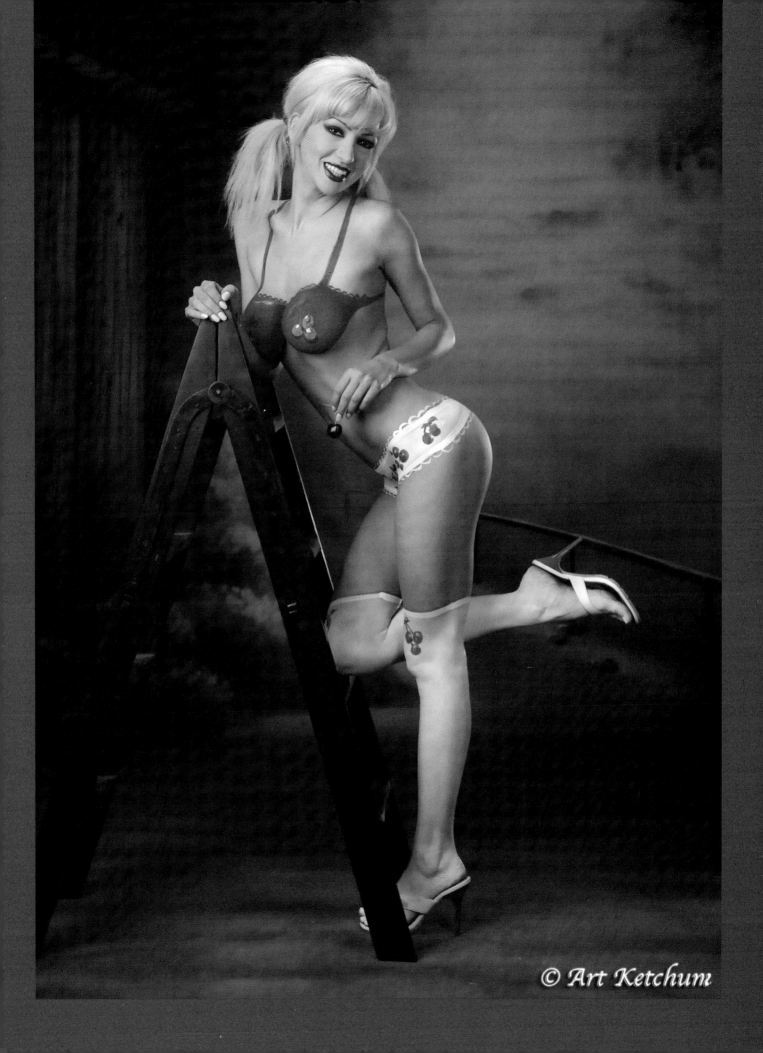

© Art Ketchum

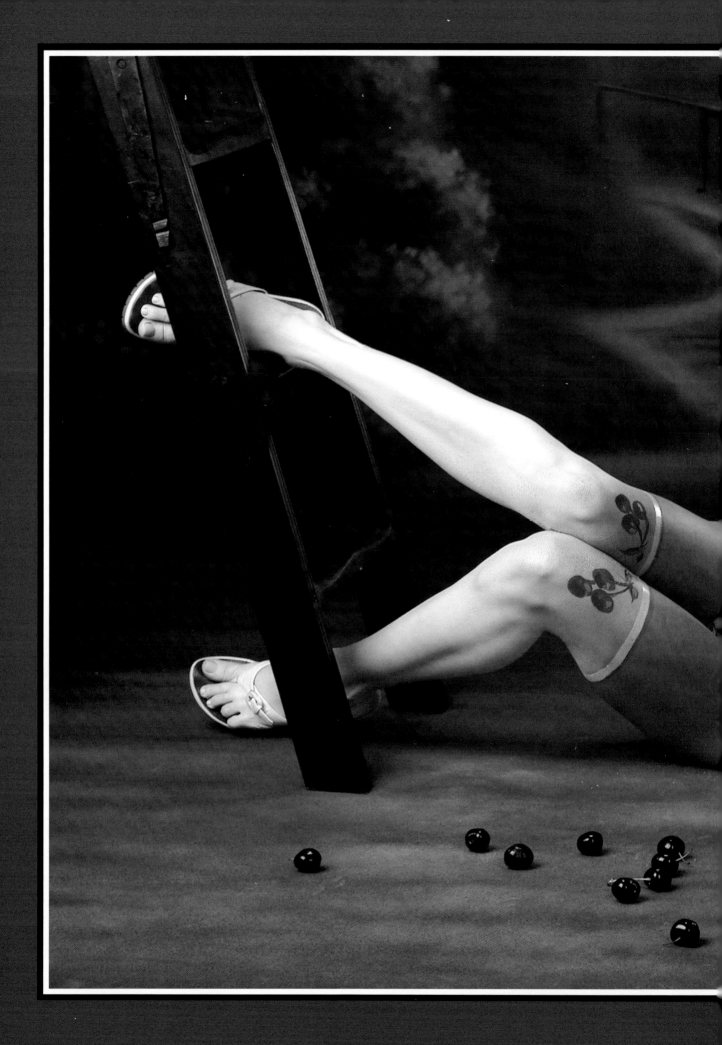

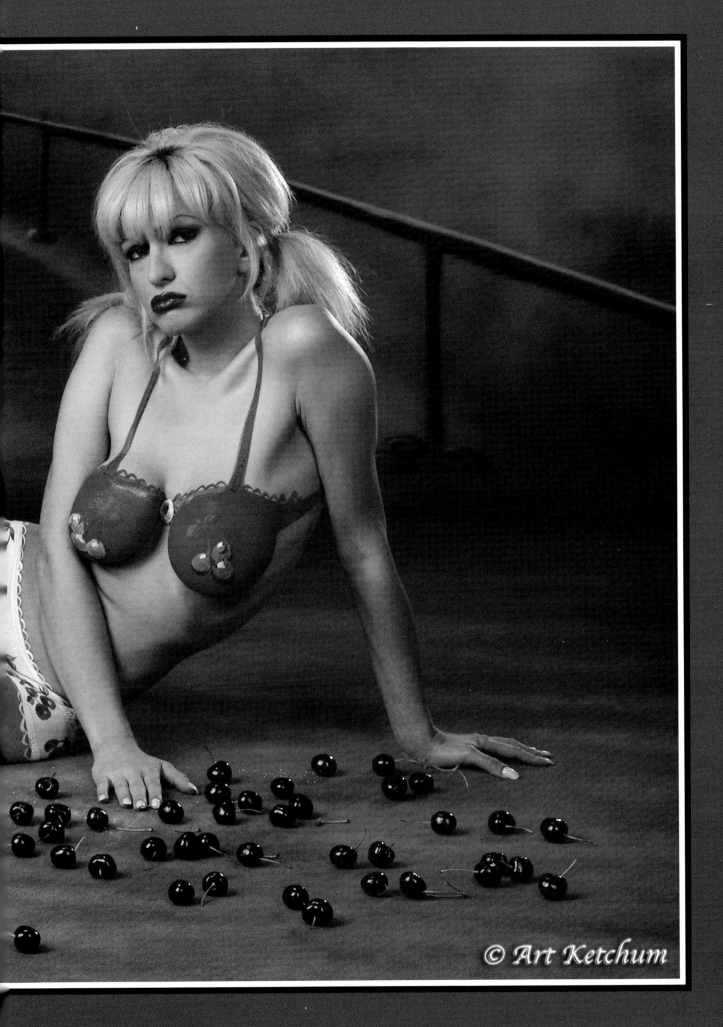

© Art Ketchum

Painting

Lingerie presents a challenge in getting the look of sheer material that requires airbrushing lightly yet consistently.

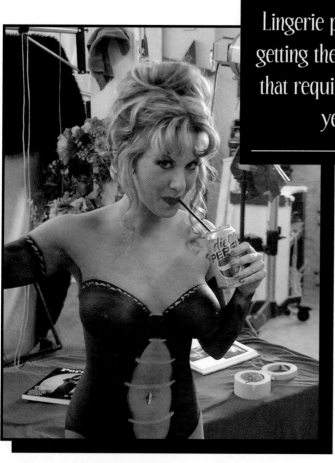

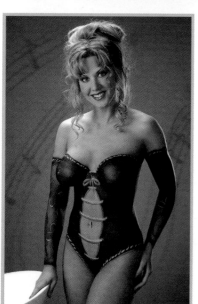

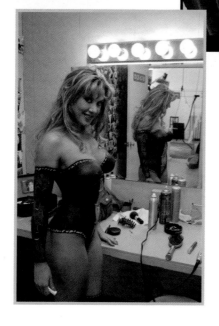

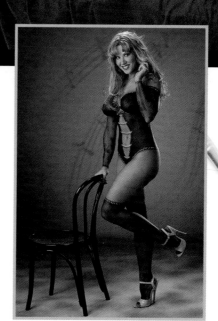

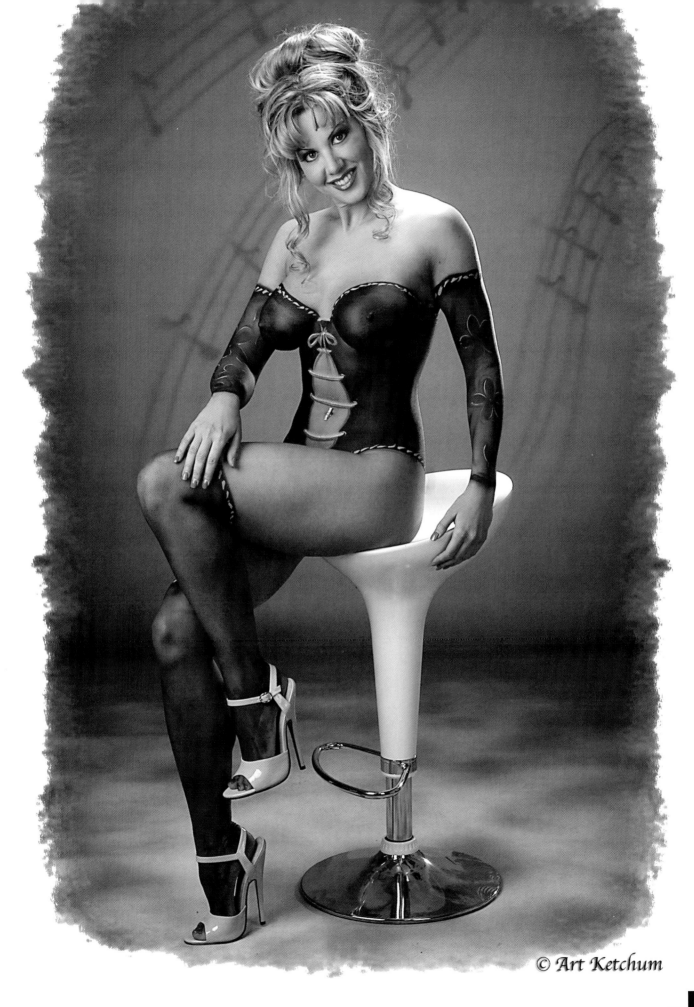

© Art Ketchum

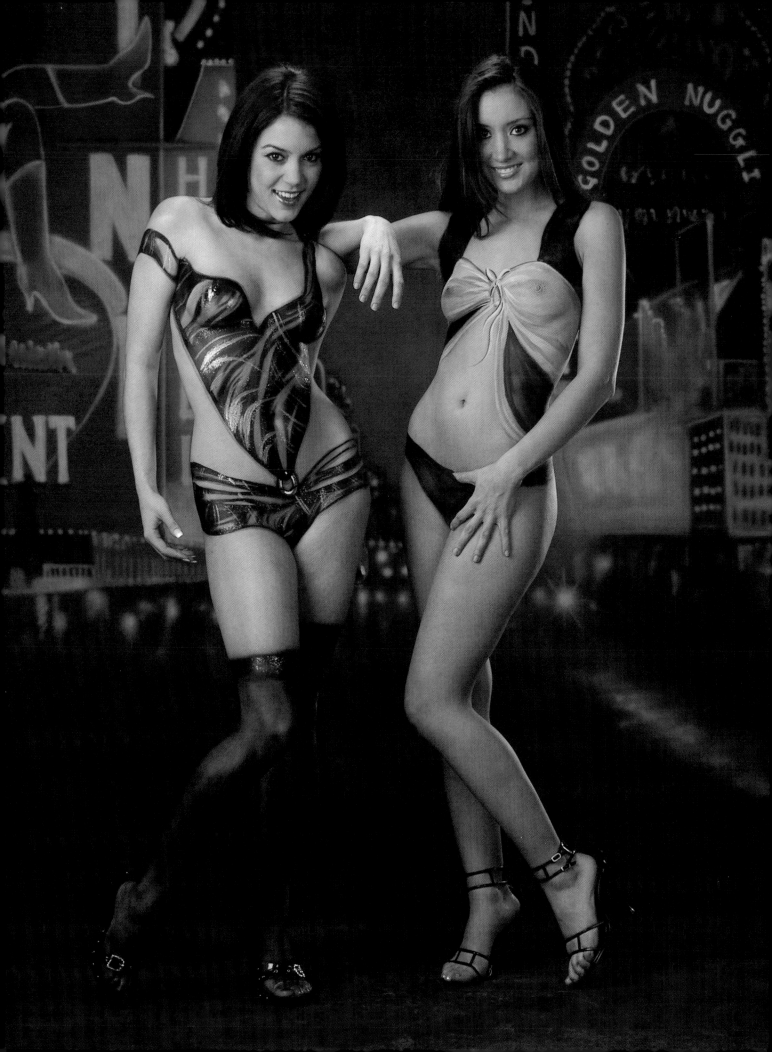

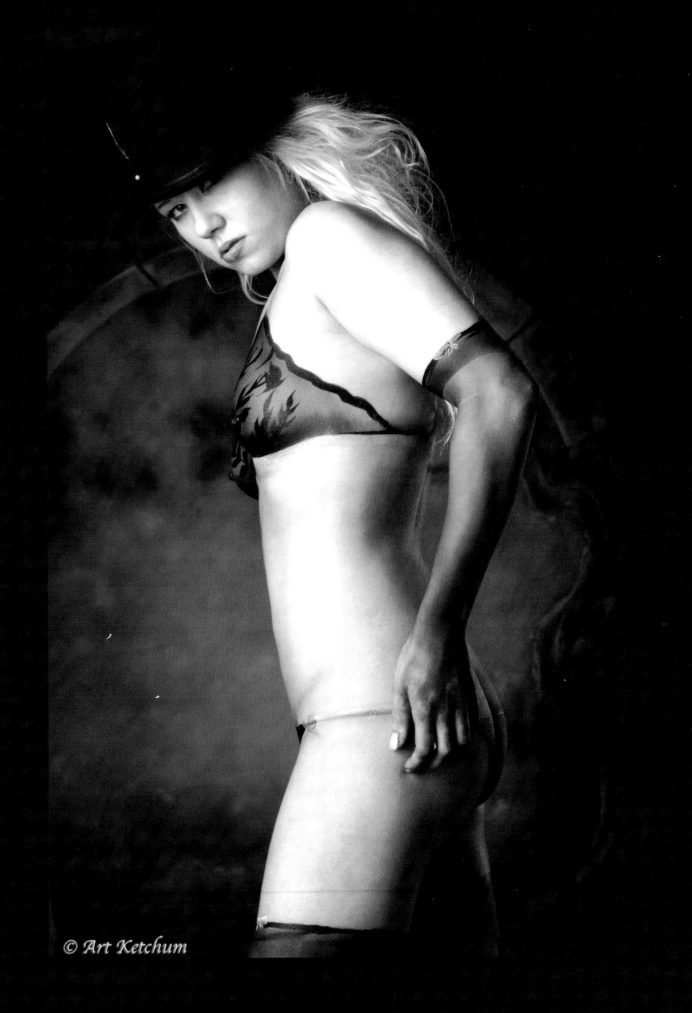

© Art Ketchum

Preparation

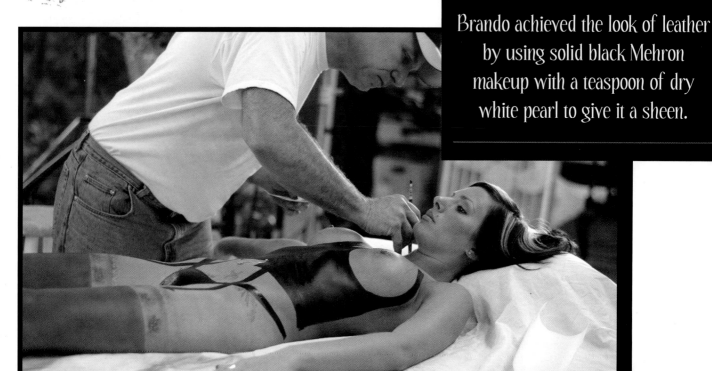

Brando achieved the look of leather by using solid black Mehron makeup with a teaspoon of dry white pearl to give it a sheen.

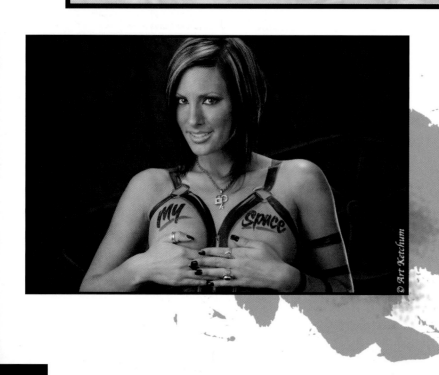

© Art Ketchum

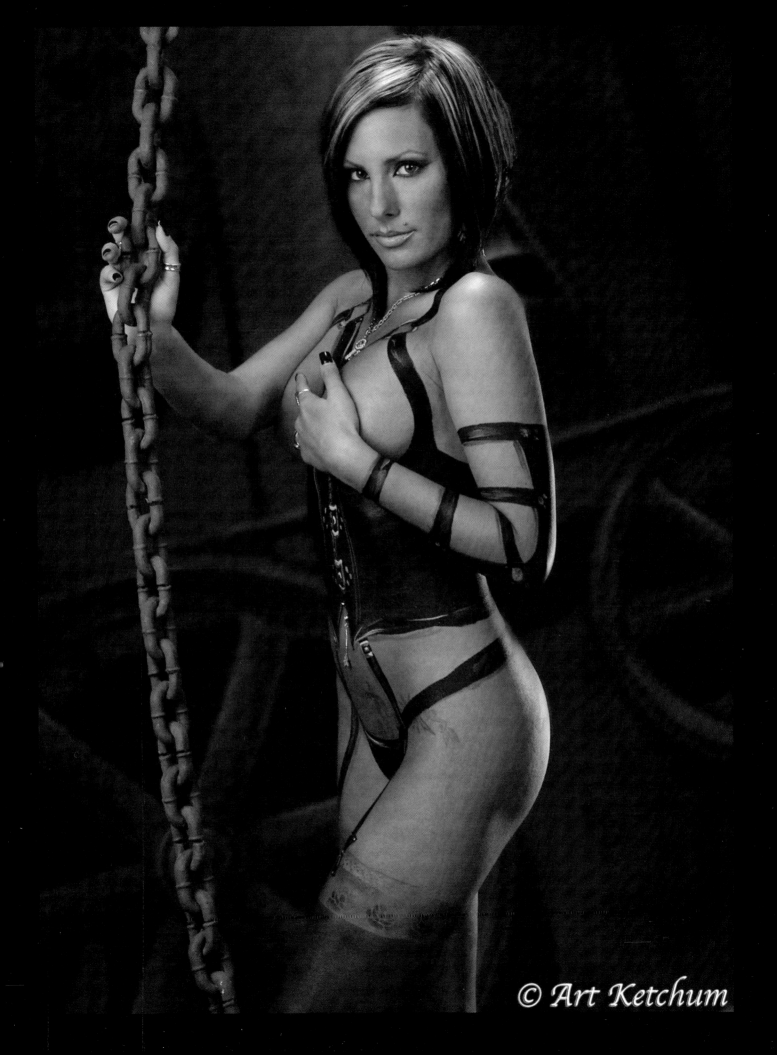

© Art Ketchum

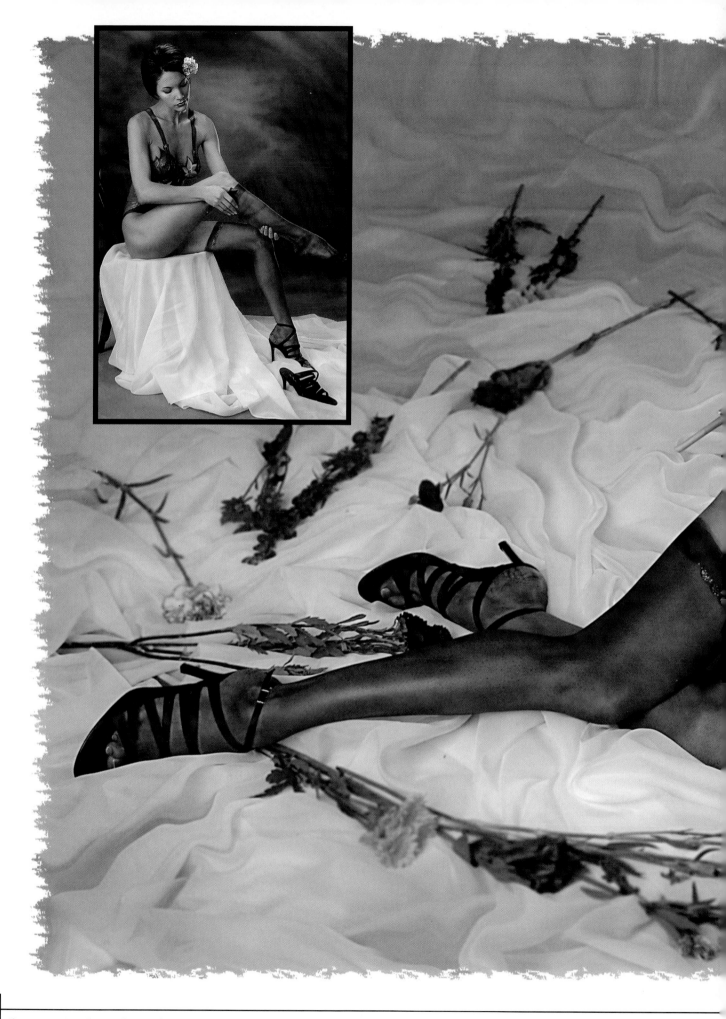

Painting the Body Beautiful

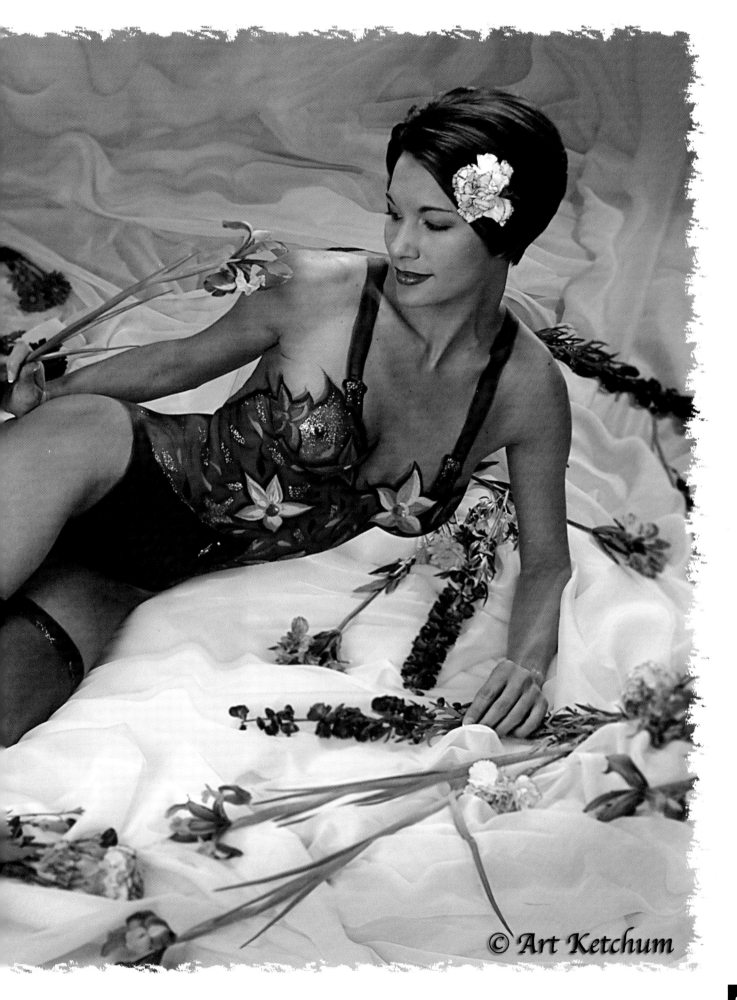

© Art Ketchum

Getting Ready

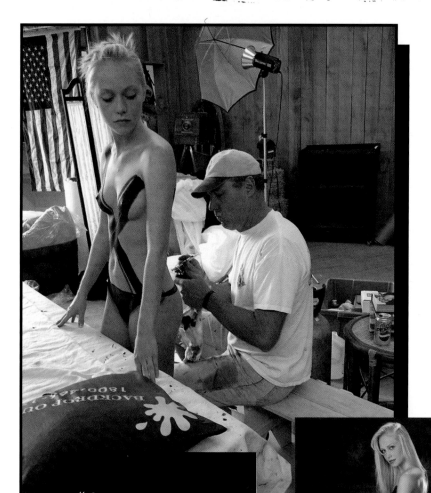

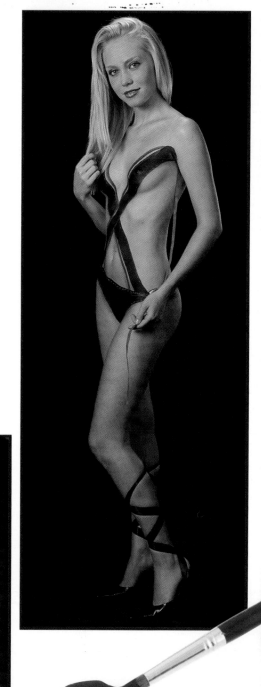

"Being painted is an amazing experience. The environment in the studio made me feel like a princess."

— *Gretchen, model*

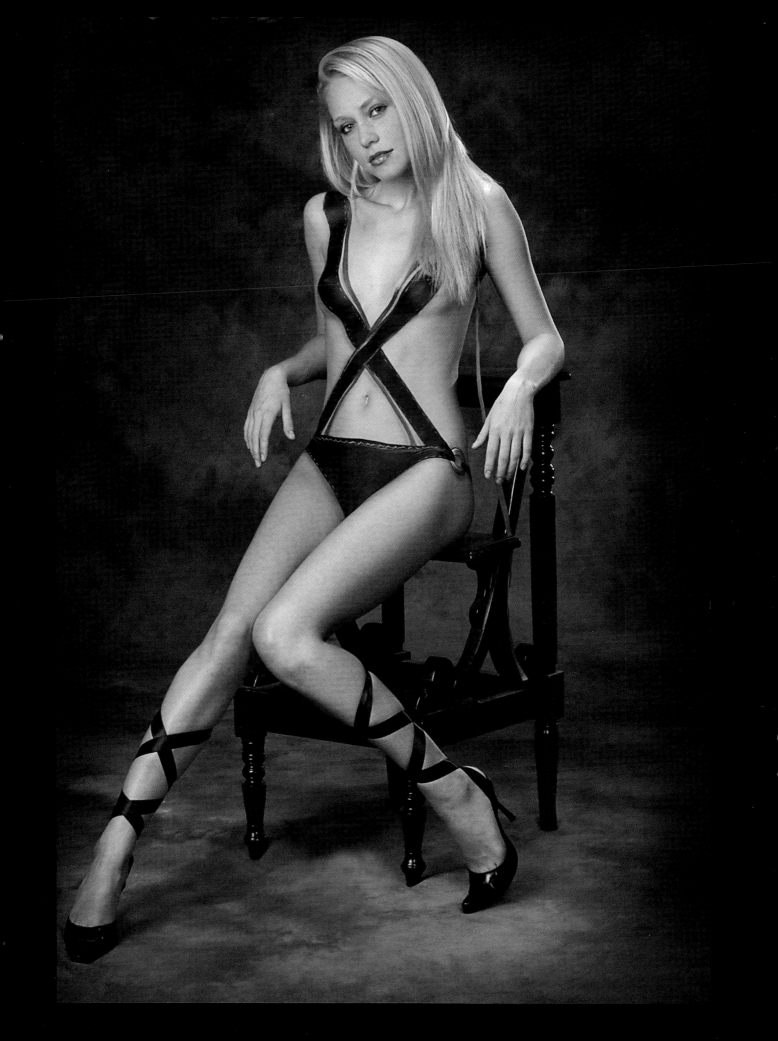

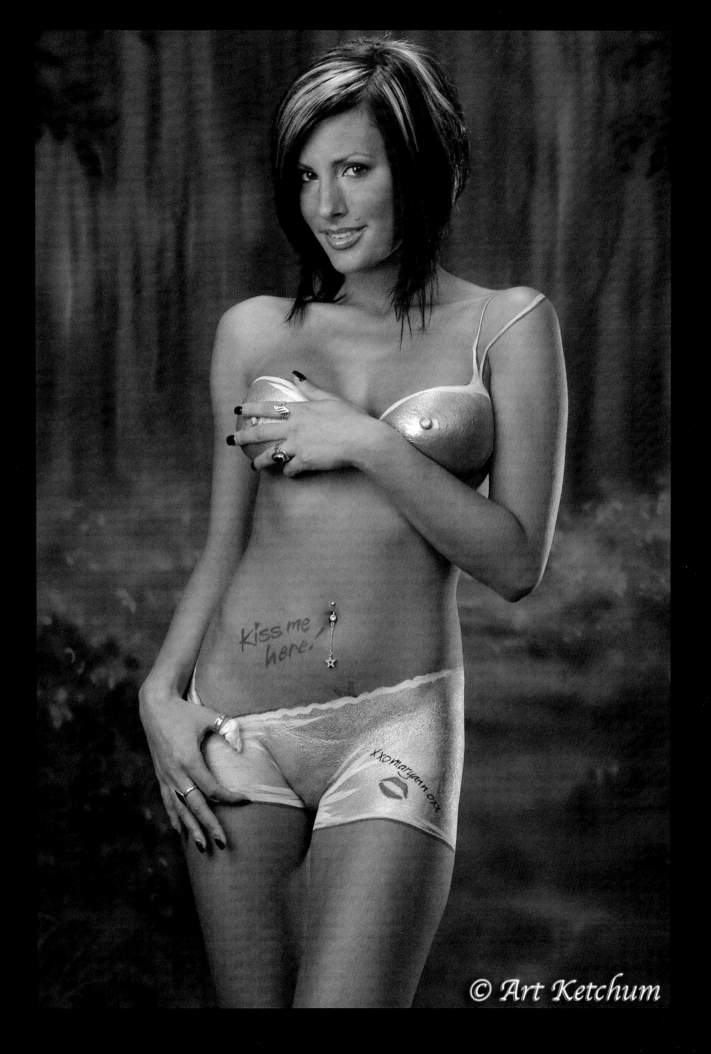

Getting Ready

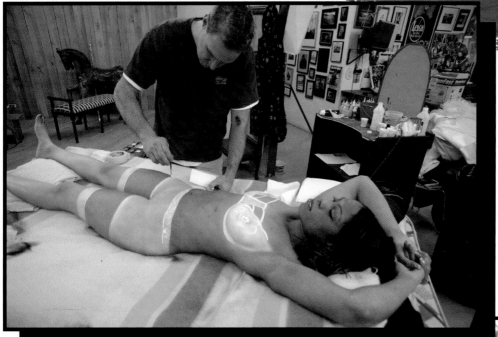

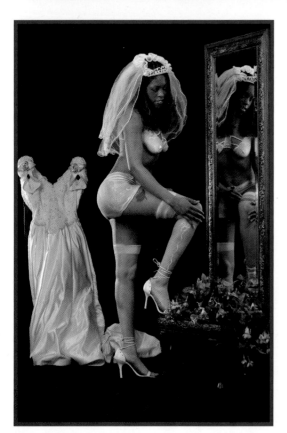

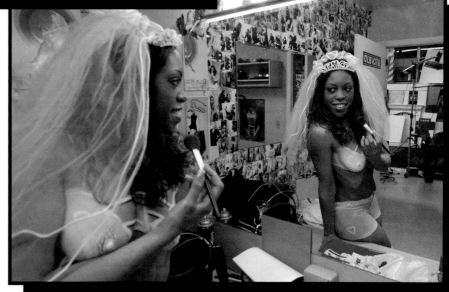

Pearlescent paint creates the look of silk and satin.

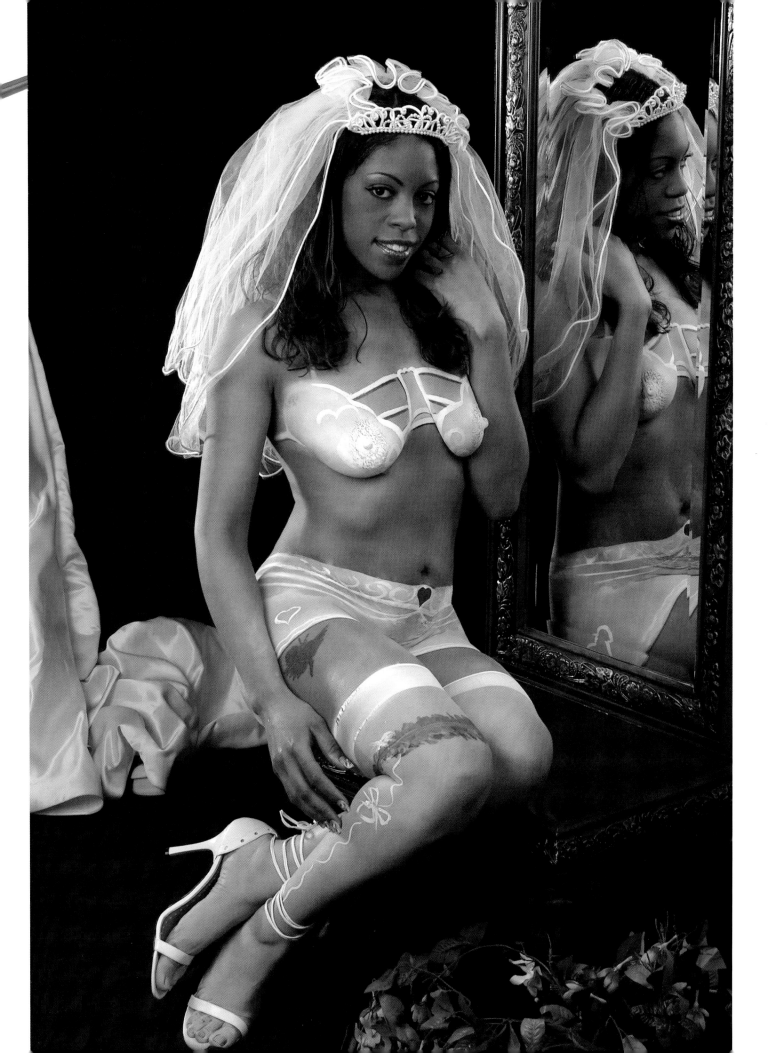

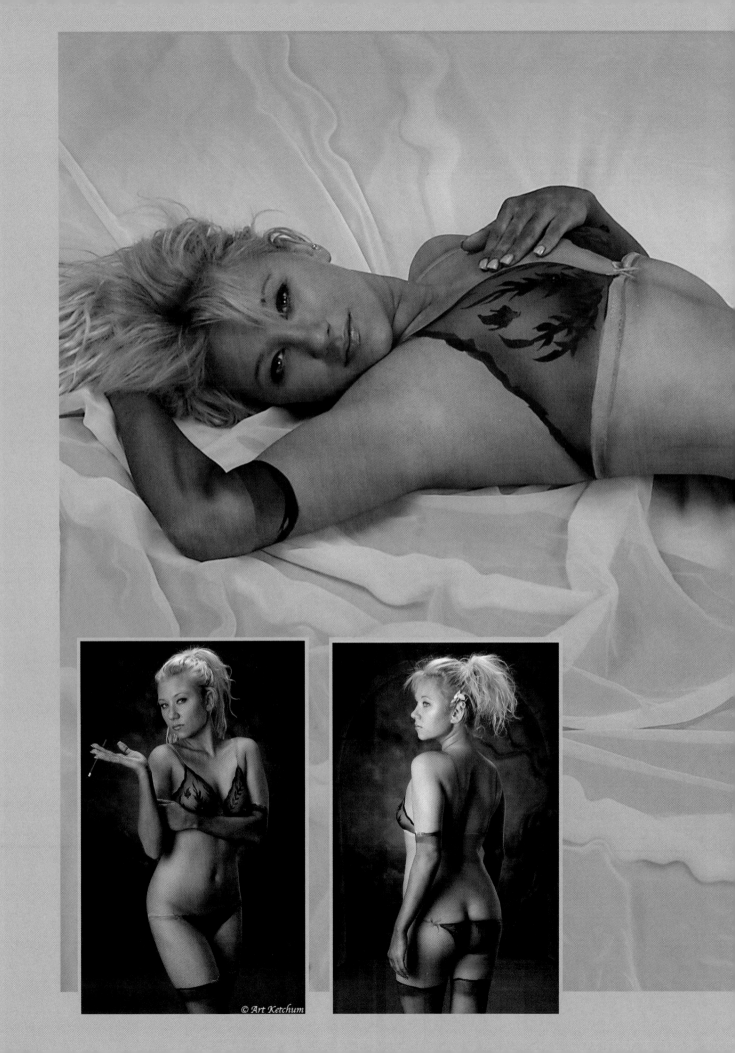

© Art Ketchum

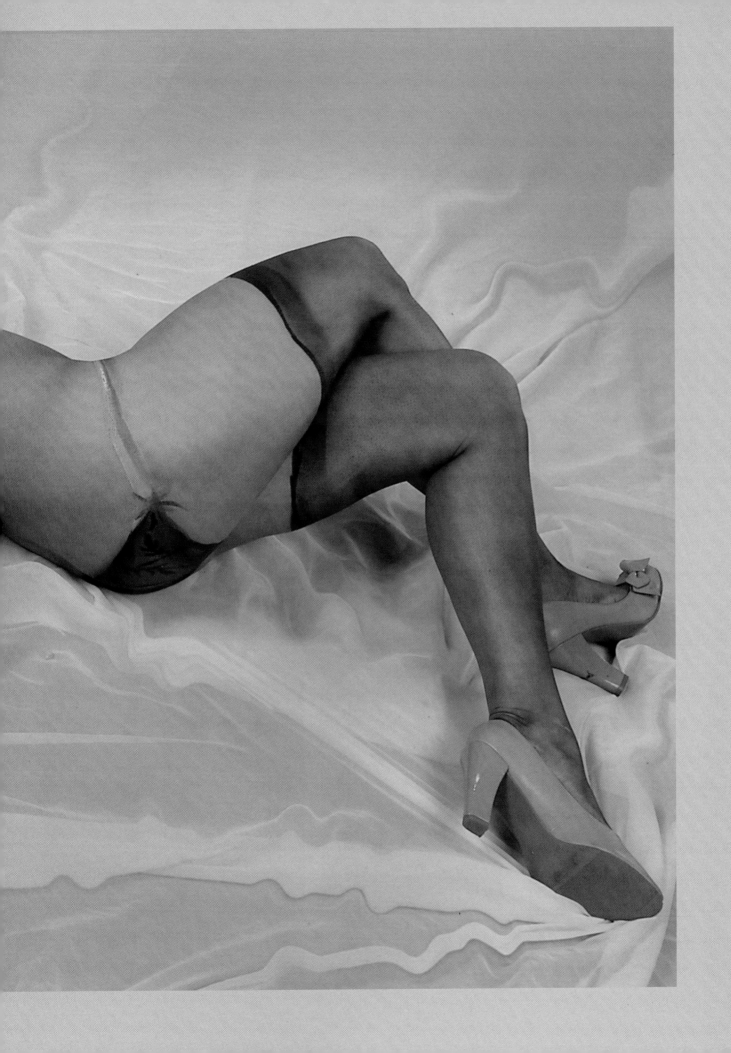

The Process

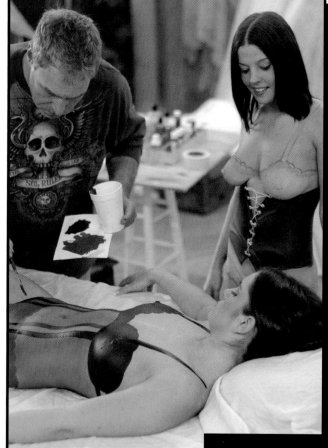

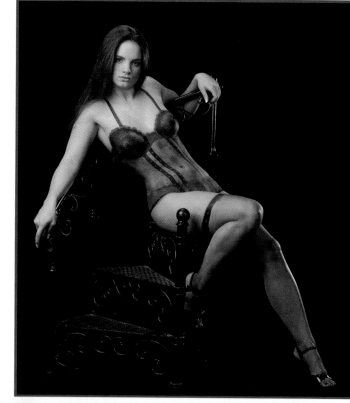

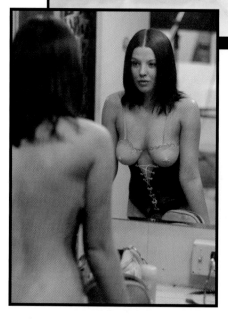

To create the red rose pattern on the model's lingerie, Brando used a stencil so it is the same everywhere.

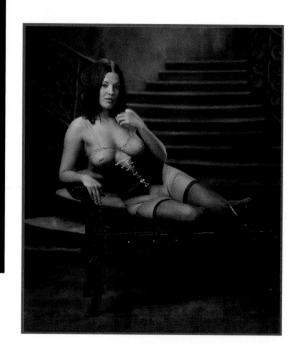

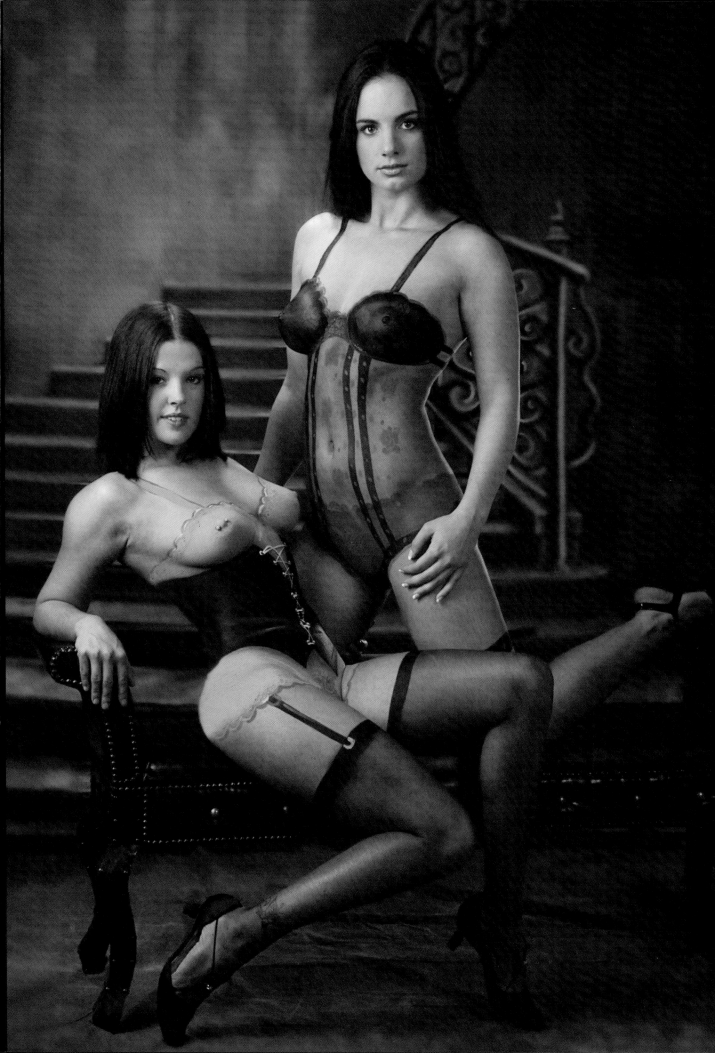

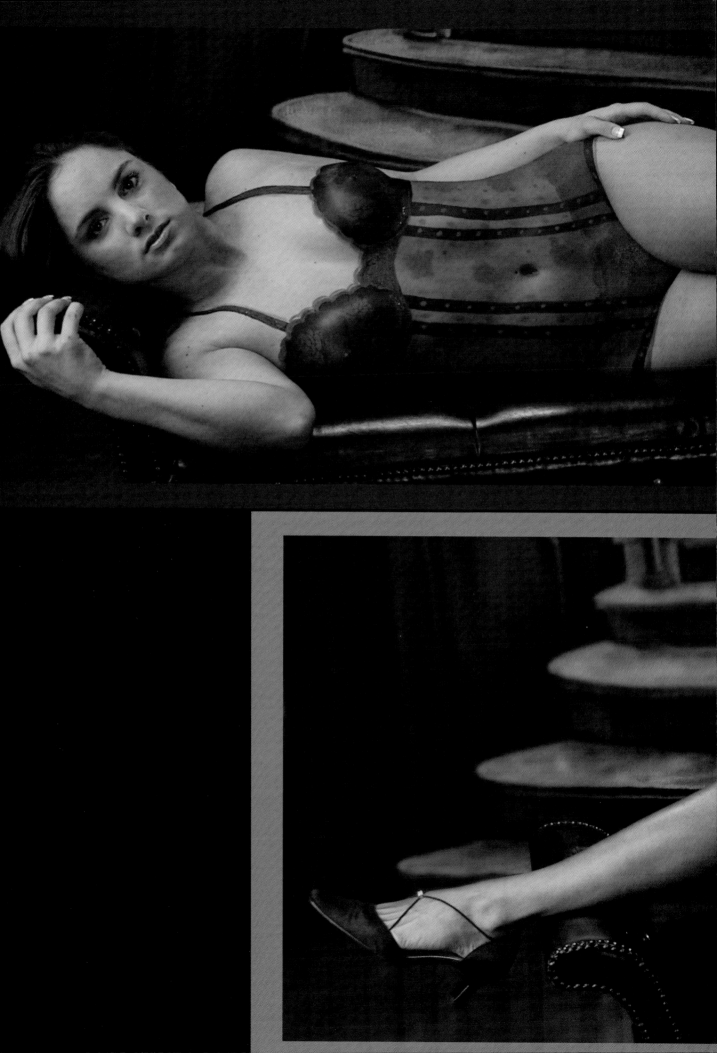

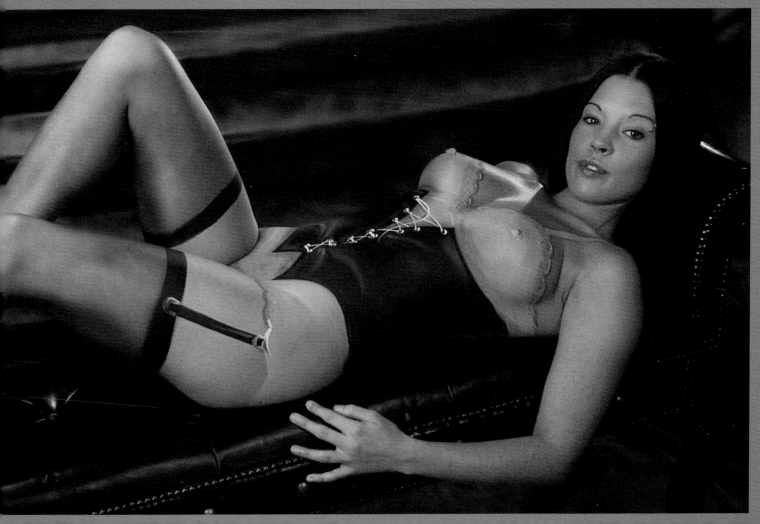

Painting

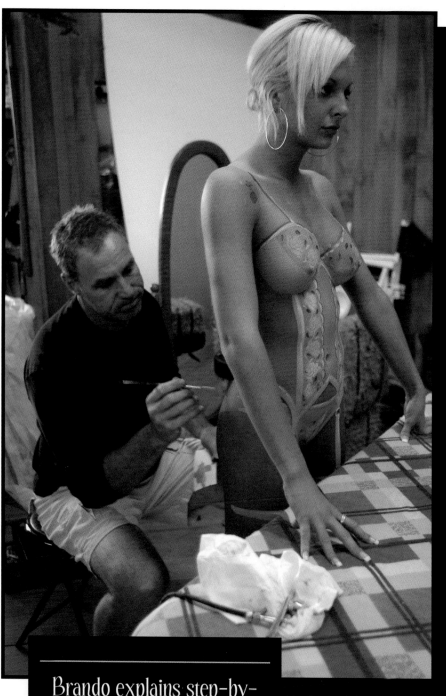

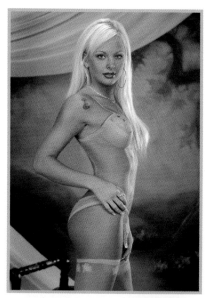

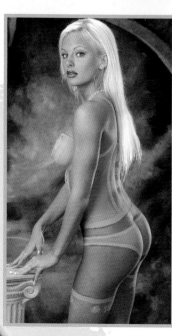

Brando explains step-by-step how this lingerie design was painted on pages 11-13.

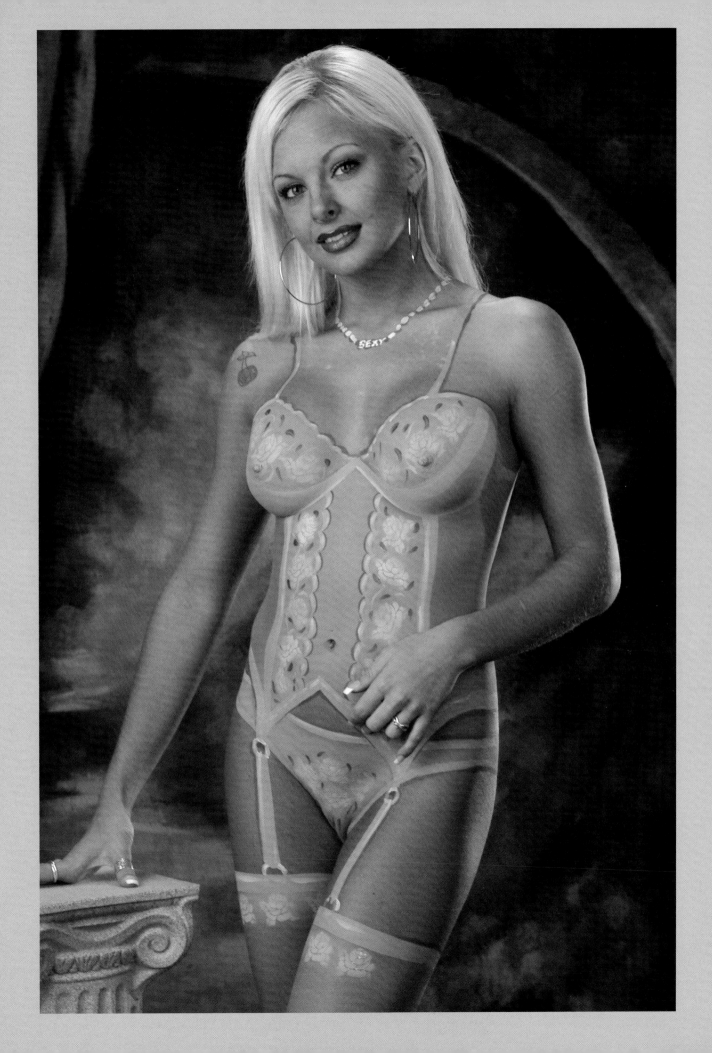

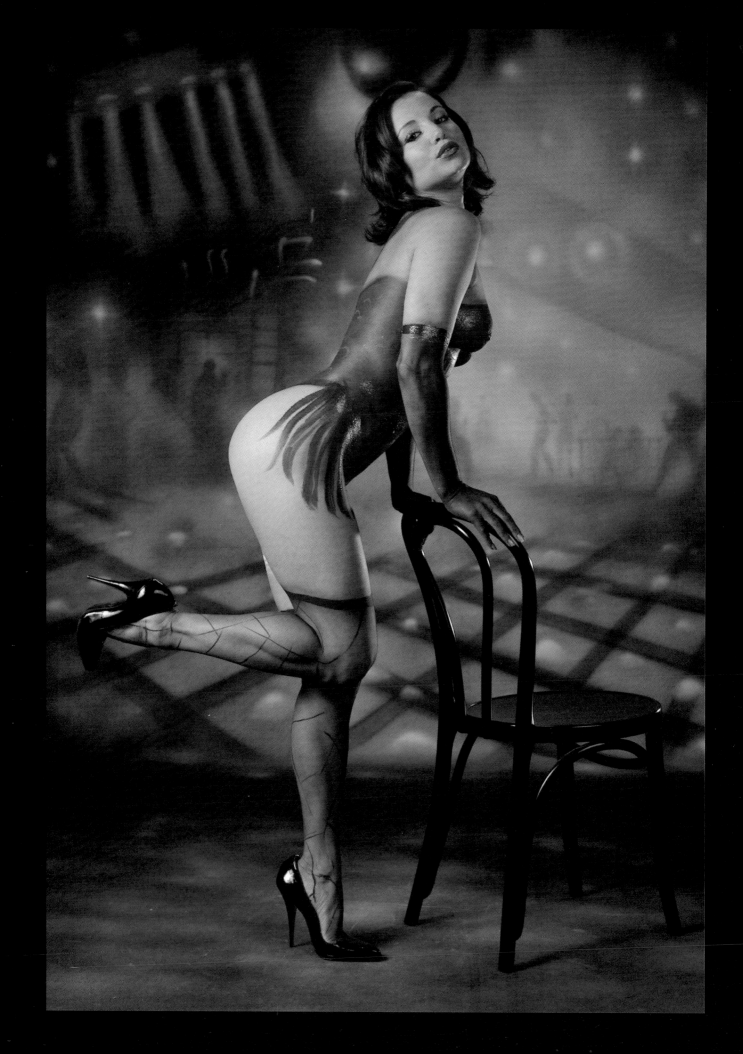

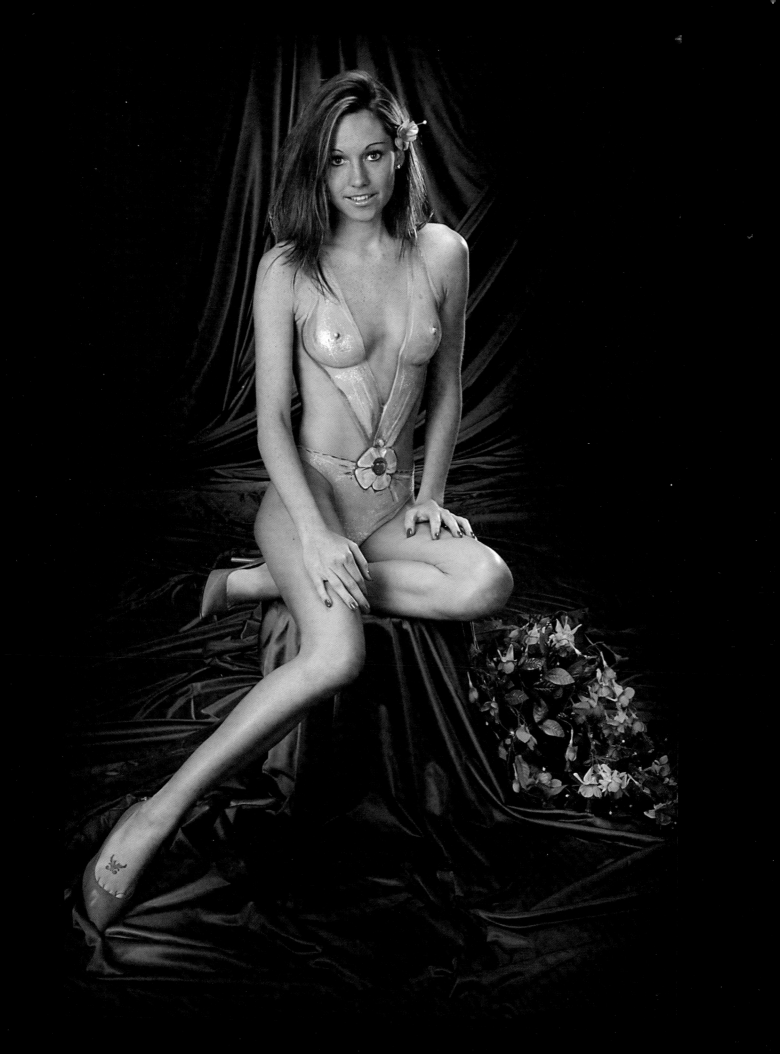

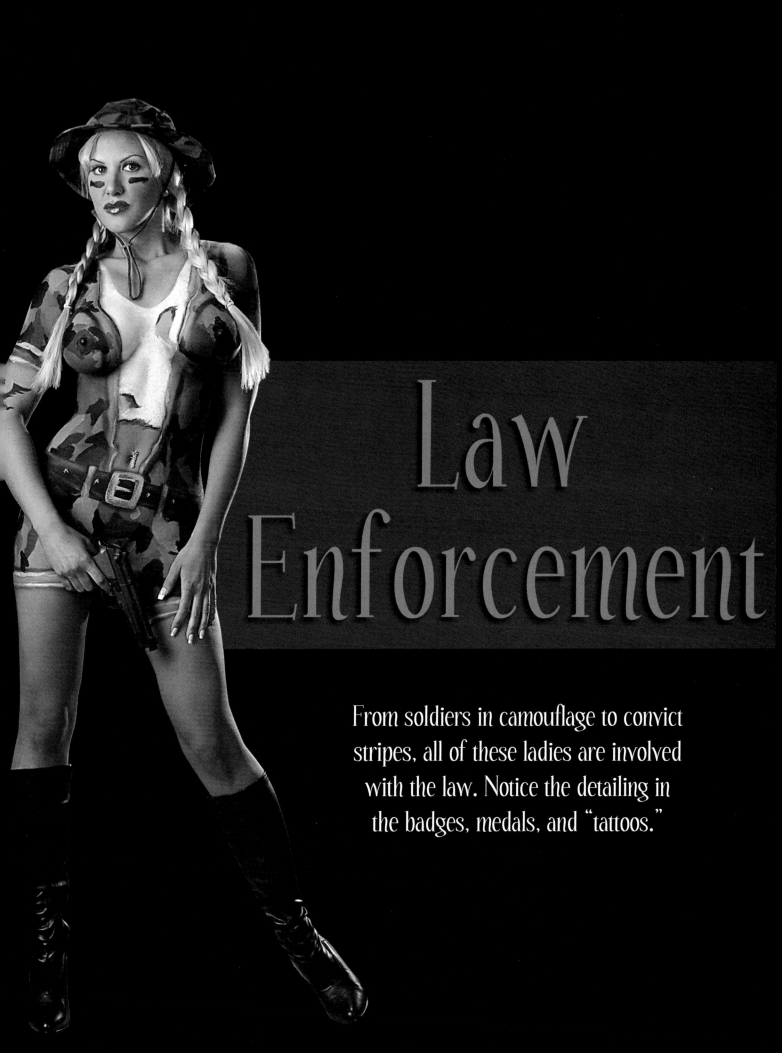

Law Enforcement

From soldiers in camouflage to convict stripes, all of these ladies are involved with the law. Notice the detailing in the badges, medals, and "tattoos."

Captured

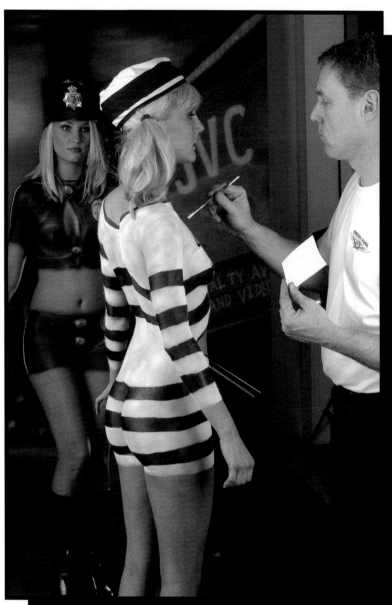

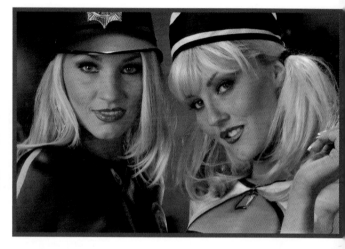

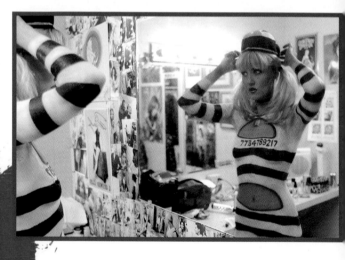

It was often necessary to touch-up painting while shooting to fix runs or smudges.

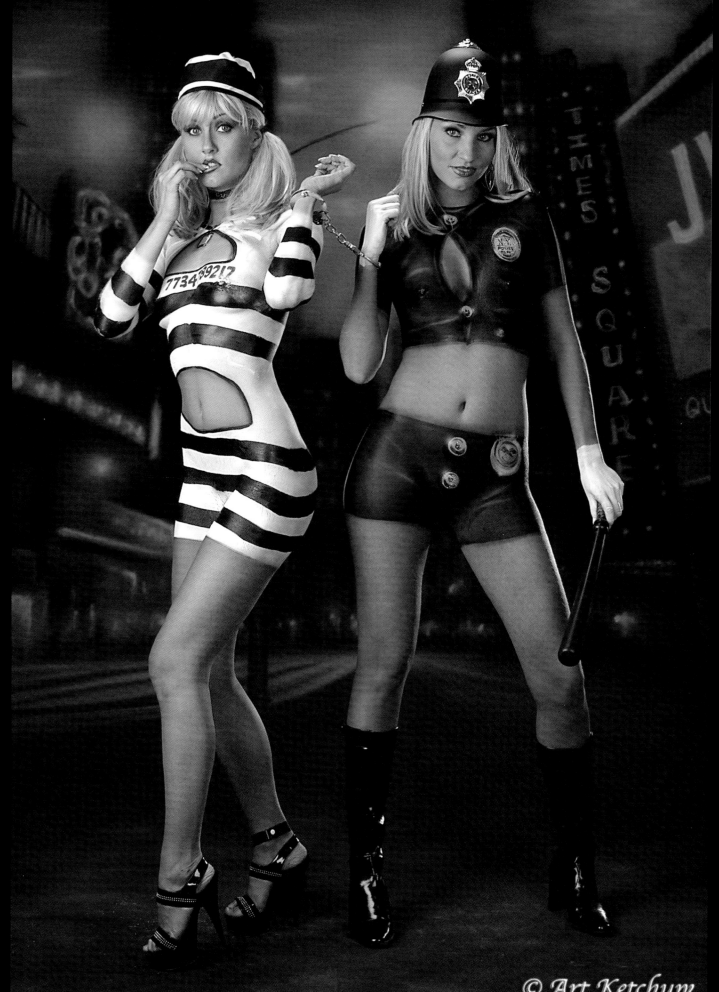

© Art Ketchum

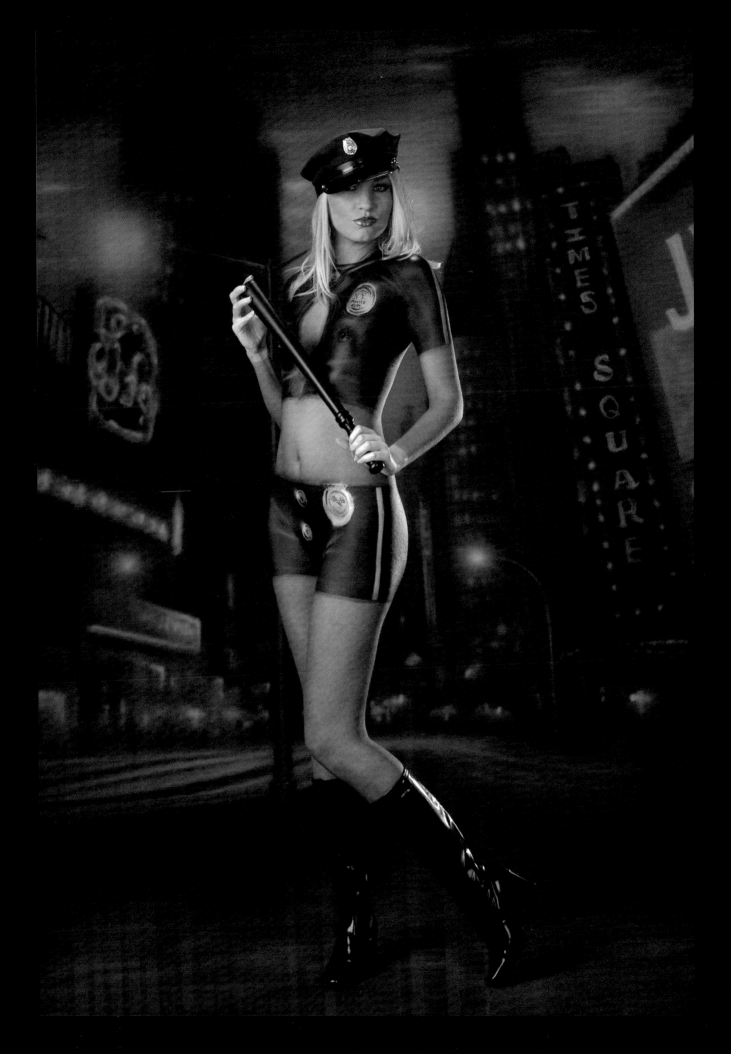

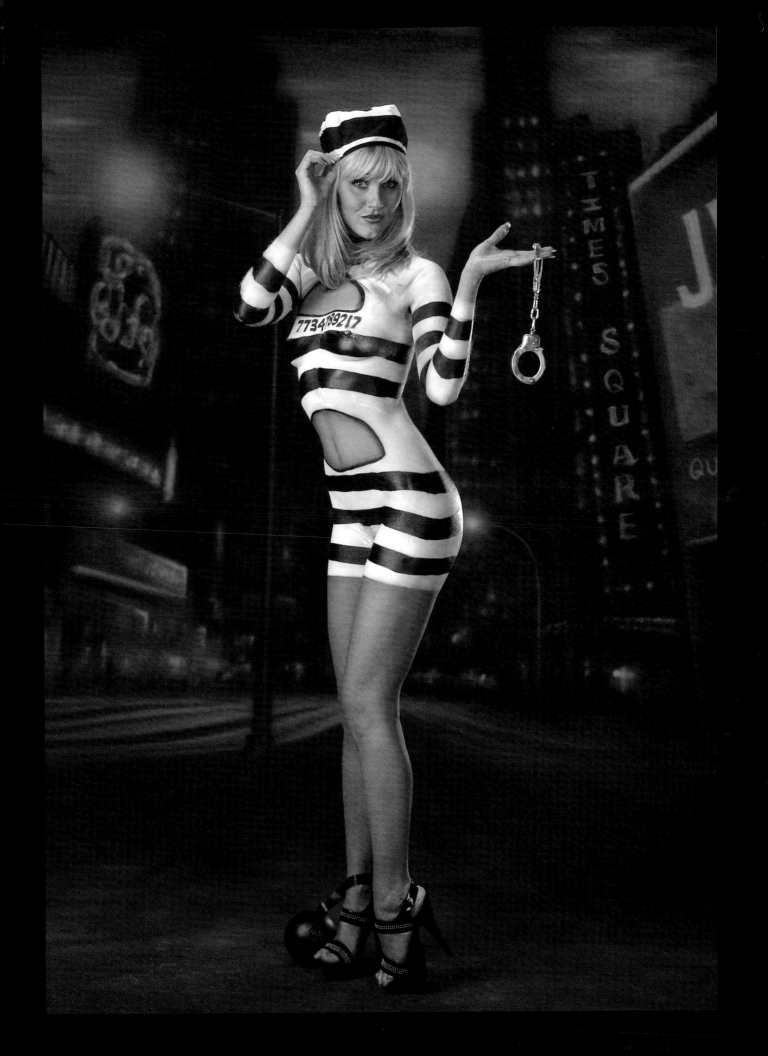

Green Beret

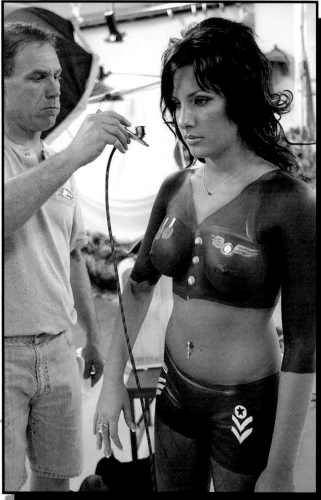

Painting the detailing — such as the buttons and medals — was the most time-consuming part of this design.

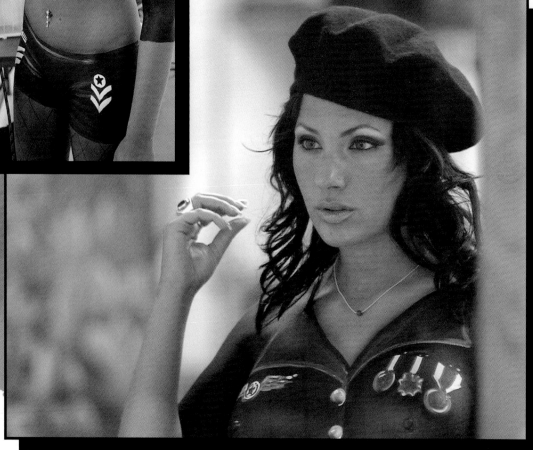

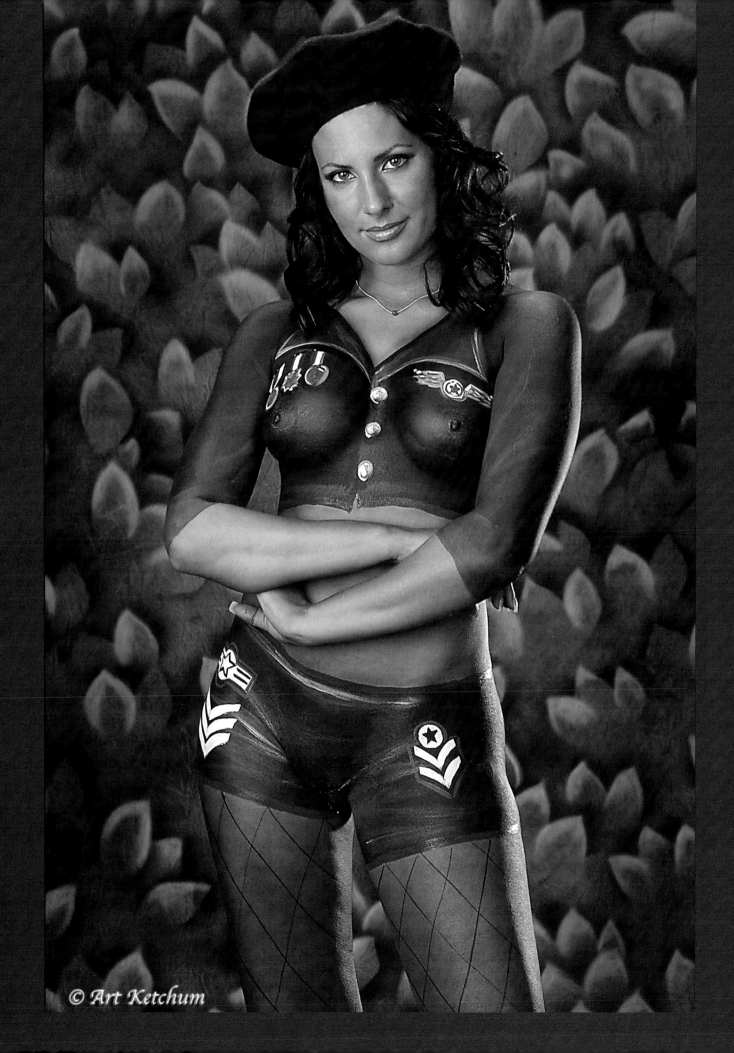

Police Officer

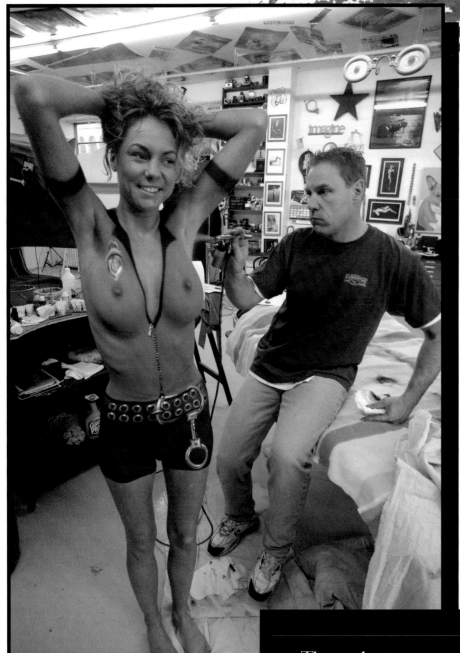

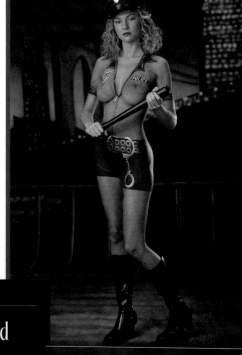

© Art Ketch

The realistic zipper and handcuffs add dimension to this design.

Painting the Body Beautiful

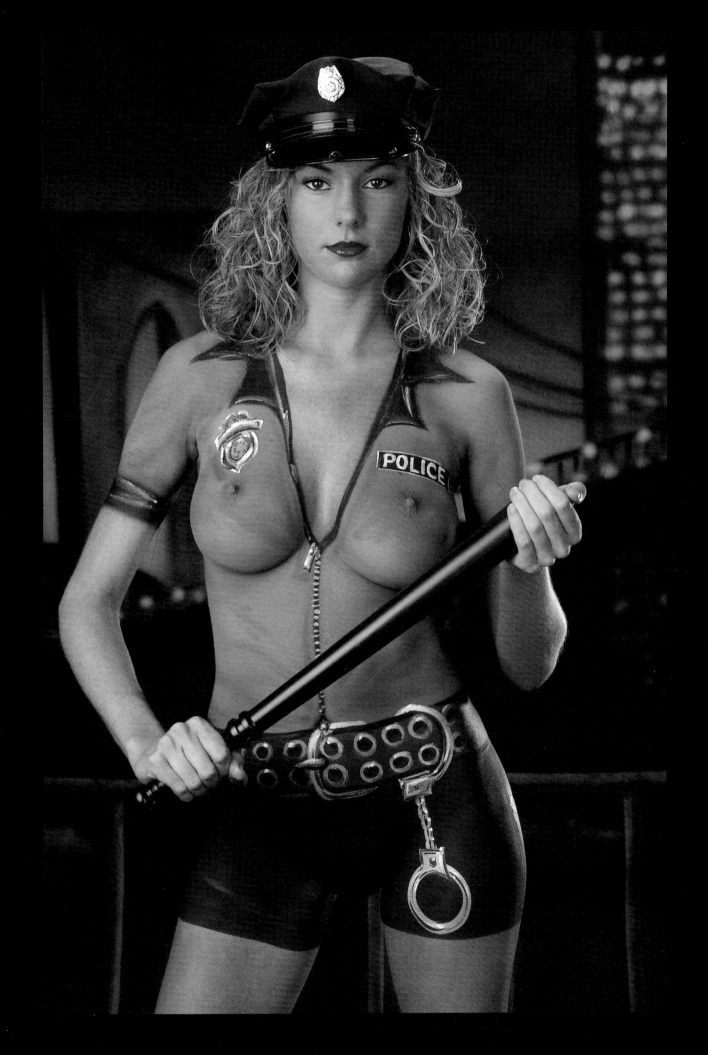

Soldier

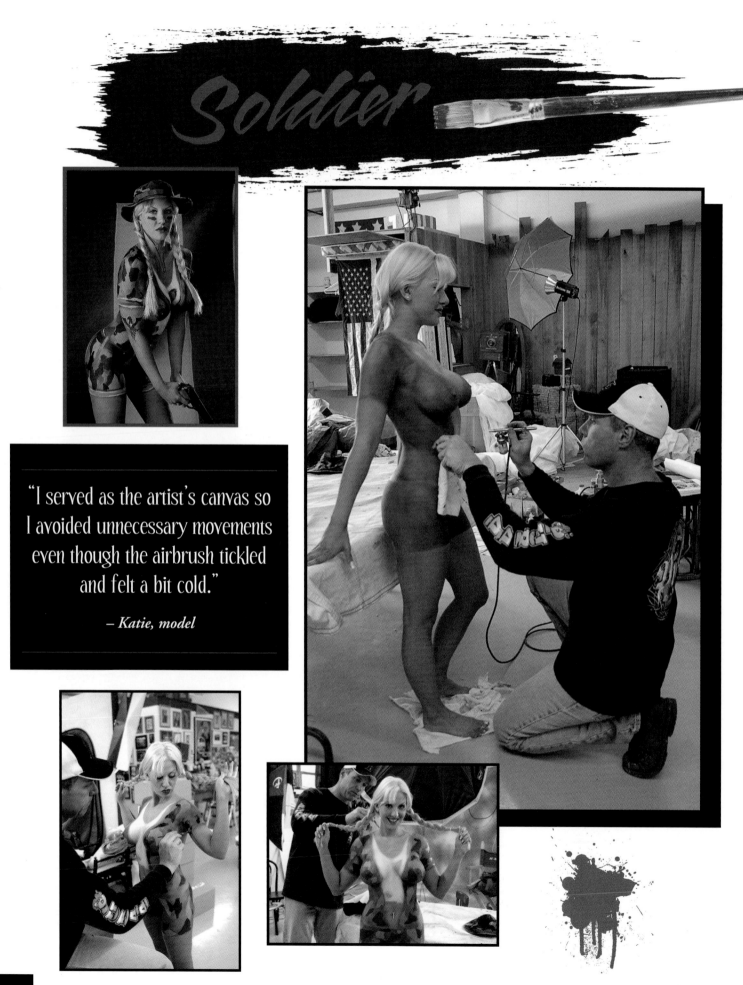

> "I served as the artist's canvas so I avoided unnecessary movements even though the airbrush tickled and felt a bit cold."
>
> – Katie, model

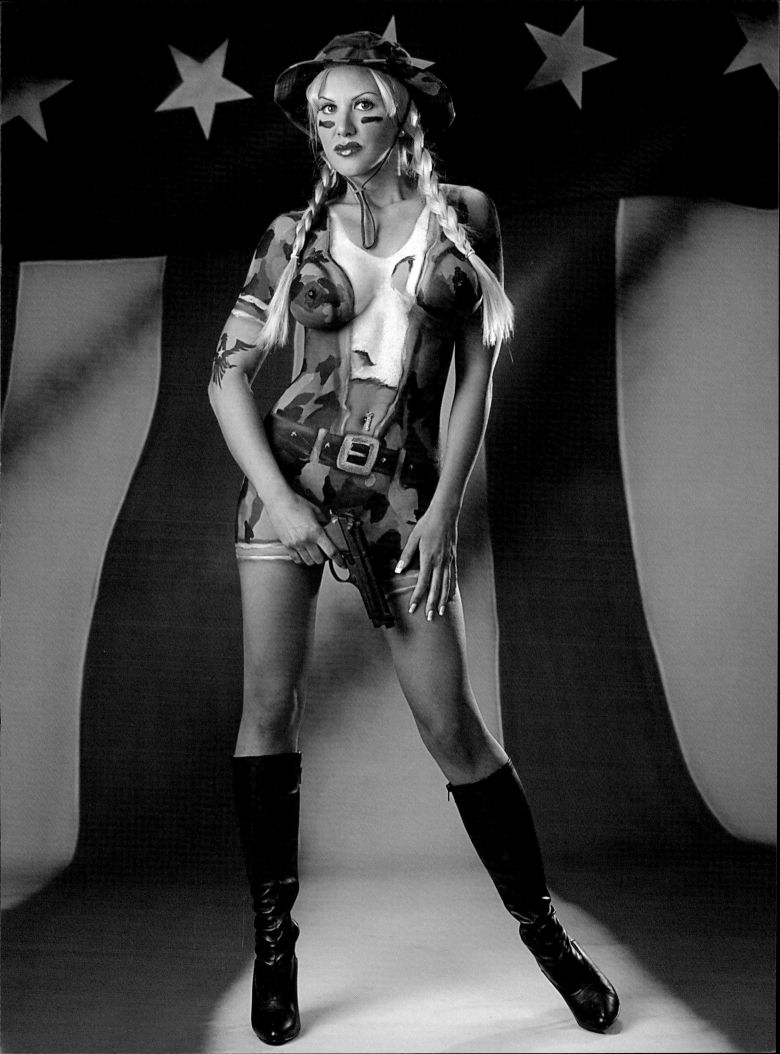

Model Index